M000251956

IMAGES
of America

BRECKENRIDGE

IMAGES
of America

BRECKENRIDGE

Dulan D. Elder

ARCADIA
PUBLISHING

Published by Arcadia Publishing
Charleston, South Carolina

Library of Congress Control Number: 2016935079

For all general information, please contact Arcadia Publishing:
Telephone 843-853-2070
Fax 843-853-0044
E-mail sales@arcadiapublishing.com
For customer service and orders:
Toll-Free 1-888-313-2665

Visit us on the Internet at www.arcadiapublishing.com

This book is dedicated to my parents, Alpha and Dorothy Elder, to the parents of friends, and to the teachers and other adults in town who took an interest in us, cared about us, and made Breckenridge "home."

CONTENTS

ACKNOWLEDGMENTS

This book has been done in conjunction with the Swenson Memorial Museum in Breckenridge, Texas, which has not only allowed the use of its extensive photograph collection but has also patiently assisted in answering questions and gathering facts. Special thanks to Lyn Clark for her guidance and facilitation of these efforts.

Much of the early history of Breckenridge was captured in the incomparable photographs of Basil Clemons, who not only produced wondrous and interesting pictures but typically dated them and often identified the subject at the bottom of the work. The Clemons photographs in this volume appear courtesy of the Basil Clemons Photograph Collection, Special Collections, the University of Texas at Arlington Libraries and the Basil Clemons Collection, Swenson Memorial Museum in Breckenridge (SMM-BCC). Special thanks to Cathy Spitzenberger at the UT-Arlington Libraries for her assistance in gathering photographs from their extensive collection.

The other sources of photographs used in this book are the Breckenridge Independent School District (BISD), with special thanks to Superintendent Tim Seymore; Swenson Memorial Museum (SMM); and the *Breckenridge American* newspaper (BA), with special thanks to Tony Pilkington. I also include several photographs by Frank Homme and believe that many of the BISD and *Breckenridge American* photographs in this book taken between 1954 and 1971 are his work, but I am unable to verify this due to lost files.

The most utilized sources of information were the works of Betty Hanna, *Stephens County: Much to Be Cherished*, the *Breckenridge American* files at the Portal to Texas History, and BISD yearbooks. The members of the Remember in Breckenridge Facebook page were a valuable resource, particularly Bennie Hart and Brenda Reynolds Ball.

INTRODUCTION

Breckenridge, Texas, was founded in 1876 as the county seat of newly organized Stephens County, situated in the rolling prairie of north central Texas. Although it averages over 28 inches of rain a year, the rains tend to come in bunches, interrupting what seem like endless droughts. Unpredictable rains and rocky soils make the area much better suited for ranching than farming.

It was a sleepy ranching and farming community of about 500 people until oil was discovered in 1917. In the 1920 census, the population had crept up to 1,846. Major oil discoveries were made in early 1920, and the boom was on. By the end of that year, the population had risen to 30,000, with many living in tents or taking turns sleeping in hotel beds. The population increased by 10,000 during a single month at the height of the boom.

Over 200 wells were drilled within the city limits. Fires from these wells were a constant threat to the hastily constructed frame buildings thrown up in town to accommodate the burgeoning population. Several fires in the early 1920s burned down swaths of the growing town; fires were particularly dangerous until a water system was completed that could provide sufficient water flow to combat them.

The price of oil dropped from the $3–$3.50 a barrel range to around $1 a barrel by the end of 1920, which slowed the frenzy, but the town continued to grow, just in a more orderly and permanent fashion.

There was no government regulation or EPA to control the disposal of salt water produced by the wells or to address the oil spewed by blown wells. Over 50 years later, there remained bare areas where no living thing could survive. Some consolation could be found in the fact that the destroyed vegetation, and what would grow there absent cultivation, would likely have only been mesquite, juniper, prickly pear cactus, Johnson grass, and salt cedar, which the locals spend a lot of money trying to control.

Respectable and visionary citizens emerged in the early 1920s to civilize the wide-open boom town and build the churches, schools, and businesses that came to embody the town and will be celebrated in these pages. The First National Bank was completed in October 1920, kicking off a construction boom culminating with the 1928 completion of the 10-story Burch Hotel.

The oil boom days and their aftermath over about 28 years were recorded by a gifted and eccentric photographer, Basil Clemons. Although his home and studio was a wagon situated on a vacant lot on North Breckenridge Avenue, his work, in the form of thousands of pictures and negatives, has miraculously survived and found its way to museums, where it is being preserved for future generations.

Many of Clemons's extraordinary photographs, interesting even for someone with no ties to the town, are featured in this book. He often dated his pictures and wrote information on them to identify what was going on, helping to preserve the town's history. This express documentation, coupled with his capturing of virtually every significant event that took place in town, makes his photographs a valuable historical record of the town over nearly three decades. A special effort has been made to include Clemons photographs that have not been published in prior works and to provide a guide and context to what his pictures show.

Many pictures feature schools and school activities, school being a central part of life in Breckenridge. Athletics, music programs, carnivals, plays, and touring Southern Assembly programs were coupled with a college preparatory education as well as an outstanding vocational program. Teachers taught life skills as well, such as how young ladies were to walk in the high heels required to be worn for the junior high graduation.

The 1929 Buckaroo football team staked Breckenridge's first claim as a football town, tying Port Arthur for a state championship in the large school division on December 21, 1929, just a few months after the October 1929 stock market crash and the onset of the Great Depression. By the 1930 census, Breckenridge had shrunk to 7,569 people, and in 1940, the population was down to 5,826.

With the onset of the Depression, the oil boom was officially over. Oil prices got as low as 25¢ a barrel. No structure of consequence would be built in Breckenridge again until the late 1950s, when several functional, flat-roofed, single-story structures from identical reddish-brown brick were erected after hotly resisted bond issues finally passed: a new East Ward to replace the one that burned; a new South Ward to replace the old one, which had been condemned during the middle of a school year; removal of the second story of North Ward, which had been condemned, and a new addition to replace the removed portion; and a new band hall, vocational and agricultural building, and cafeteria and home economics building, replacing the old school building and former teacher boarding quarters that had been used for those purposes. These 1950s buildings all remain and are in use.

While the Depression stopped the building in town, it could not kill football. Still playing in the large school division through 1950 (there being only large and small at the time), the green-and-white-clad Breckenridge Buckaroos, led by coaches Pete Shotwell, Eck Curtis, Cooper Robbins, Joe Kerbel, and Emory Bellard, continued to thrive. Through 1959, the Buckaroos had a cumulative record of 315-96-23, an astonishing 72.58 winning percentage.

The players were typically undersized and outmanned, but they were all football players whose skills had been honed going back to the elementary full-pad competitions. The 1958 championship team, which defeated the AAAA state champion Wichita Falls and was named by the *Fort Worth Star Telegram* as its Team of the Century, has 28 players in its championship photographs, seven of whom were freshmen and sophomores brought up from the B team for the playoffs.

While Breckenridge's total of state championships has been exceeded in the modern era (although it was still tied for seventh all-time as of 2013), what still sets it apart from all other schools in Texas is this *Hoosiers* element. Until 1951, it had success against all comers. Even when new classifications were created, Breckenridge played up a class most of the time and, in its heyday, always played the best of the best of the largest classification.

With its squads of 20-something undersized players, generally playing much larger schools, its teams were beloved underdogs who drew fans and followers far outside its countywide school district. Noted for great sportsmanship, playing clean, and outworking and outsmarting opponents, the Buckaroos' popularity in the 1950s rivaled that of the Fort Worth Masonic Home Mighty Mites of the 1930s and early 1940s.

Eck Curtis, who took over as head football coach from Pete Shotwell in 1935, introduced two core traditions to Breckenridge. The first was waterless practices and games. He did not want "waterlogged" players. Players took a handful of salt tablets after practice or a game and could drink water then, but none during practice or a game, even during two-a-days. Joe Golding, the highly successful coach at Wichita Falls in the late 1940s through 1961, also subscribed to the waterless athletics theory. In these times when hydration is stressed, this seems almost dangerous, but it worked very well even with undermanned rosters where most played both offense and defense. This tradition continued in Breckenridge at least into the early 1970s, although warm lime Gatorade, mixed by coaches in troughs using powder and water hoses, was introduced to two-a-days around 1970. The second tradition was reserves standing at all times on the sidelines with their helmets on, ready to enter the fray at a moment's notice. In the 1950s, the Buckaroo green became so feared that the team used solid green uniforms for both home and away games, claiming it could not afford a second white uniform.

One of the problems of being from Breckenridge is that even the good friends you meet later in life, no matter how kind they are, can never really believe your stories of the little town that became a city overnight and then shrank back, or your tales of the little school that whipped all comers in football for years. There is the 10-story Burch Hotel, since 1970 a bank, and the full-blown YMCA as evidence of a more glorious past, but not much else to bolster our stories.

Besides its interesting history, those who spent their formative years in Breckenridge love it because it was such a great place for kids. The YMCA had swim lessons and library story hours for little kids and indoor athletics. Little League, Babe Ruth, and American Legion baseball played in fancy uniforms, close to what the major-leaguers wore. Full-pad football (for the older and better kids who actually played; and partial pads, to the extent available, for the younger children) started in fourth grade, complete with cheerleaders and games played in Buckaroo Stadium against the other elementary schools before decent crowds. Boys choir taught boys an appreciation of good music, and they also participated in Junior Rodeo and 4-H. And all of it was just the right price—free.

While Breckenridge is classified as having a humid subtropical climate, it is mysteriously coupled with perpetual drought. It is humid during August two-a-days and too humid for an evaporative/swamp cooler to work (although poorer folks tried anyway), but rain was always needed. Unlike farming, which concerns itself with when rains come, moisture is always welcome in ranch country. The cheerfulness and good will associated in other places only with Christmastime is on display in ranch country every time it rains.

Something about Breckenridge's climate, at least in the 1950s and 1960s, got the balance of nature out of whack periodically and resulted in invasions of unwelcome visitors. There was a mice invasion in the late 1950s. Many children were assigned traps by their parents and paid a penny per trapped mouse. Cats were very popular around town but were overwhelmed. This was followed by a snake invasion, word getting out to the snake community, in particular rattlesnakes, of unlimited mice in town. A rattler in a dresser drawer was not considered an upgrade over mice by everyone.

The 1960s brought periodic cricket invasions. Merchants swept the crickets off their sidewalks every morning, and crickets accumulated in vacant store windows. The streets were covered with crickets at night, adding a special clicking sound to the usual road noise and a memorable stench to town. One year blister bugs were substituted for the crickets. While quieter and less numerous and pungent, they dispelled the notion that their ability to give you a blister was a myth. When *The Ten Commandments* was shown, or when Sunday school lessons covered the Biblical plagues, it was personal to children raised in Breckenridge who understood these events in their gut far better than kids raised in less exciting environments.

A kid could fish for green or red-tinted crawdads in the creeks with a piece of string and bit of meat tied to the end. There were simple pleasures that would not be approved of today, like riding your bike in the fog behind the mosquito sprayer, snow sledding on an old hood pulled behind a car, or a country ride in the open bed of a pickup with the sweet smells of cut hay and rushes of cool air going through dips. There were no helmets to mess with when riding a bike or a horse, and mother's extended arm at unexpected stops was all the seat belt a kid needed. There were summer evenings playing outside with the smell of chicken fried steak wafting through the air back when everyone was slender and no one had even heard of cholesterol.

Breckenridge had its distinctive traditions. If you Google Socco or Sock-O or Socko or anything of that sort, nothing like the game played at the YMCA or in school PE will show up; it is strictly a Breckenridge term. It was dodge ball played with volleyballs where you could advance to the free throw line to bombard the opponents, with an added assault element where you could sneak up behind the opponents bombarding your teammates and drag them across the free throw line as another means to eliminate them. Because of the similarity in names, many Breckenridge boys grew up thinking they maybe liked soccer, when nothing could have been further from the truth.

No equivalent of the coronation of the Buckaroo Queen, the highlight of the year for kids who dreamed of living in fairy tales, can be found on Google other than some references to something

similar in Mineral Wells for a time. Who would think of missing this event, with royalty and glamour in full color, and the chance that Eddie Hyatt might do a comedy monologue or the star quarterback, Harry Ledbetter, might be in a group who sang "Michael Row the Boat Ashore" better than the Highwaymen? Pictures of those events through the years appear in this book.

Before every home football game, the band led the student body, which got out of school early, on a parade downtown for a pep rally held at the blocked-off intersection of the two major highways through town. Often the cheerleaders would climb onto a flatbed (provided by a local oil service company) parked in the intersection to lead the cheers.

I invite you to play "Find Nail's Café" as you go through these pictures. No place in Breckenridge was more beloved than tiny Nail's Café. There is a 1926 parade picture where it is not there, and a year later, there it is in its original, free-standing, four-stool array, but it is not Nail's yet. It started as Black's Sandwich Shop and was taken over by Mrs. Nail's relatives.

Estella Nail, known to most as Mrs. Nail, hocked her wedding ring to buy out her relatives' interest around 1932. In the beginning, Mrs. Nail arrived at the café at 5:00 a.m. to prepare for breakfast and stayed open until 10:00 p.m., seven days a week.

She stretched her hamburgers with bread, but they were still delicious and affordable. Some claimed she could have fed the entire high school with a pound of hamburger and a loaf of bread. If someone ordered a ham sandwich, she might walk next door to Piggly Wiggly to get the ham, avoiding unnecessary inventory that might spoil. Customers were sometimes sent to get more buns. She charged only 5¢ for a cup of coffee because her husband, J.C. (or Clovis), said that was all a cup of coffee was worth, but there were no refills at that price. She was also famous for her pies and plate lunches. All the food was excellent, and Mrs. Nail was definitely in charge; in fact, it was more often referred to as "Mrs. Nail's" than Nail's Café.

It was our town, where the parents we never fully appreciated, until they were gone or aged, looked after our happiness and gave us the gift of a carefree childhood. It is hoped that these pictures will remind readers of the town in which they were raised and now and then retrieve bits and pieces of their past, when times were simple and they were much loved, rag knots and knot heads though they may have been.

One

BEFORE THE BOOM

The Comanches made their last major stand in 1874, and by 1876, when Stephens County was officially organized, there was no significant resistance to white settlement. On July 4, 1876, Breckenridge was named the seat of the newly formed county.

E.L. Walker was elected the first judge of the new county. Breckenridge's main street, Walker Street, is named after him. On November 19, 1876, E.L. and Melina Walker parented the first child born in the new town of Breckenridge and, in honor of that event, named him Breckenridge Stephens Walker. No man would play a bigger role in the early development of the new town than the appropriately named Breck Walker.

Breck Walker purchased a controlling interest in First National Bank and became its president. He partnered with Judge Clifton Mott Caldwell, also of Breckenridge, to form the Walker-Caldwell Water Company to bring water from the Clear Fork of the Brazos River at Crystal Falls and built the first water system for the booming city. The Walker-Caldwell partners were also highly successful in the oil business and developed the Walker-Caldwell area around the present East Elementary School. The original East Ward Elementary School was marked above its entrance as the Walker-Caldwell School. Breck Walker was also involved in the lumber business, ranching, and other business ventures, and in civic and church affairs.

According to one source, by 1900, Stephens County's population had grown to 6,466, with 650 of those residing in Breckenridge. Other sources say that in 1900, Crystal Falls was slightly larger than Breckenridge.

There are few photographs of pre–oil boom Breckenridge, perhaps because there was little to photograph. Unlike the downtown brick and stone structures built during the boom, many of which remain, the original buildings were mostly frame structures that long ago disappeared.

For this book, whose focus is on structures those alive today remember, the best that could be done, for the most part, was to use photographs, several by Basil Clemons, of buildings that were constructed before the boom.

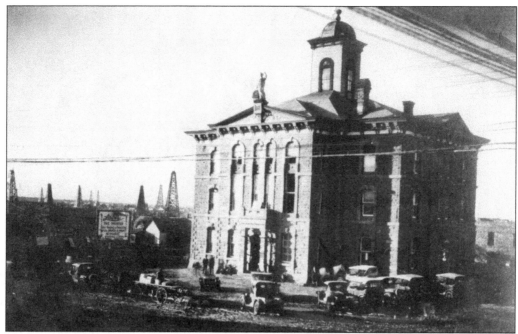

The contract was let in 1883 to build the old red sandstone courthouse, pictured here in 1920. The building was designed by the noted Dallas architect J.E. Flanders, who also designed the beautiful Shackelford County Courthouse still in use. The entry arch of this building remains. The rest of the building was demolished in 1927 after the new courthouse was completed. (SMM-BCC.)

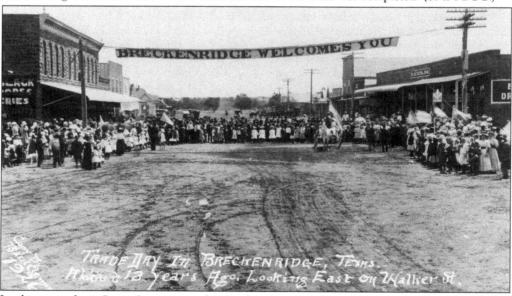

Looking east from Court Street around 1913, this photograph shows what would later be Walker Street/Bankhead Highway. At this time, it stops about where Breckenridge Avenue was later built. A crowd is in town for trade days. The two-story stone building on the left still stands at the northeast corner of Court and Walker Streets, albeit with a different facade. (Basil Clemons Photograph Collection, Special Collections, UT-Arlington Libraries.)

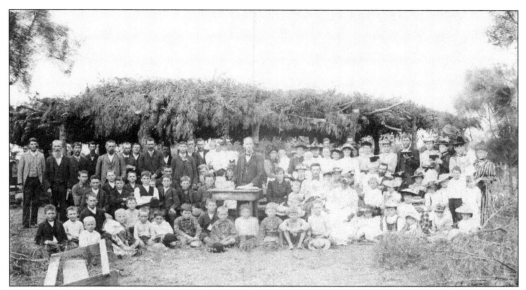

This 1892 brush arbor camp meeting took place in Eolian, Texas, southwest of Breckenridge. Mesquite branches were stacked on a wooden frame to create the shaded arbor. Prior to the oil boom, there were many small farming and ranching communities such as Eolian scattered throughout the county. James Solomon Zant Jr., who is buried in nearby Plum Branch Cemetery, is standing second from the left. (Author.)

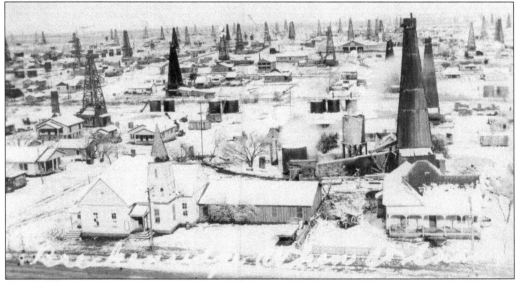

The Methodist church (with steeple) was built in 1877 at the northeast corner of Miller and Walker Streets. It was later sold to the Church of Christ. There was no bridge across the creek at this time. The long white building with three entry arches on the hill is the all-grades school that was in use until the new high school and Central Grammar School were completed in 1922. (SMM-BCC.)

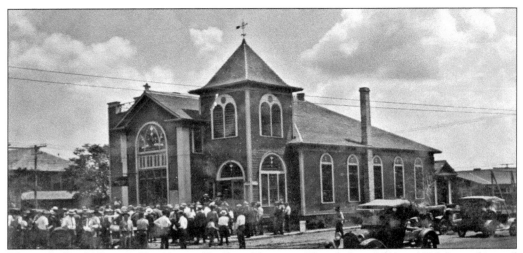

This is the Little Brown Church, used by First Christian Church from 1910 to 1925. It was located on the northeast corner of Williams Street and Breckenridge Avenue, just north of the present church. It replaced the first church, built in 1890 at the location of the present church, which was also used as a school and community center. (SMM.)

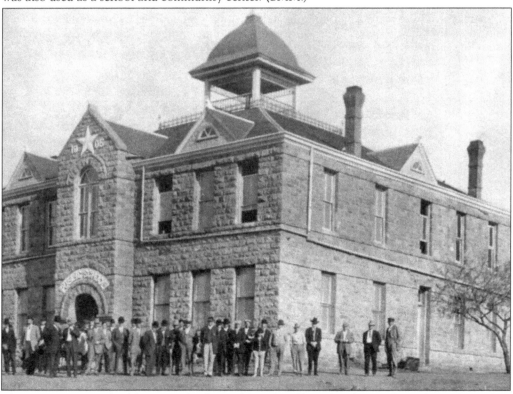

This nice two-story building was the first public school built by the Breckenridge Independent School District as organized in 1904. It is said that it was built on High School Hill in the general location of the present high school. The less elegant one-story school had replaced it according to pictures from the 1920s. (SMM.)

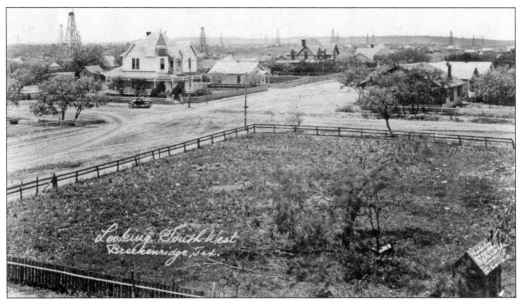

This white three-story Queen Anne home is on the southeast corner of McAmis and Williams Streets. It has been identified as the Stoker house. The top story was removed and relocated to Cutting Street. The many-gabled house two lots west, which appears to be where Melton-Kitchens is now located, is identified as the Curry house. (SMM-BCC.)

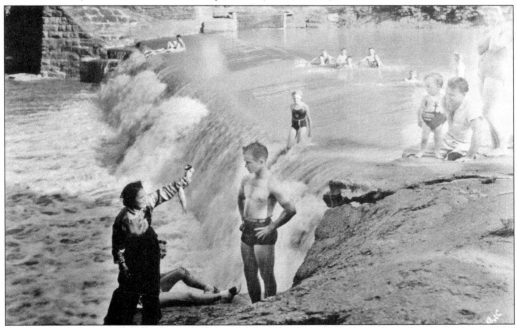

The Clear Fork of the Brazos River is pictured at the Donnell Mill in Eliasville, Texas, a popular recreational area for Breckenridge residents. This was the site of several drownings when the water was "up," most notably of Ronnie Bills in 1962. Early Spanish explorers called the Brazos River Rio de los Brazos de Dios, "River of the Arms of God." (Basil Clemons Photograph Collection, Special Collections, UT-Arlington Libraries.)

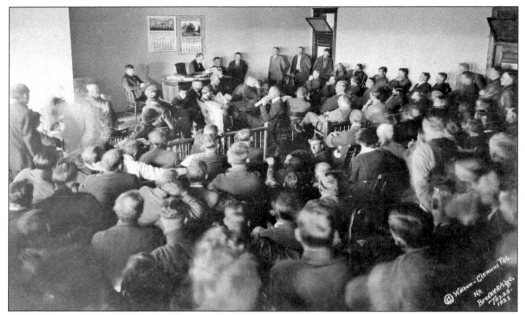

A 1921 jury trial is seen in the district courtroom of the 1883 courthouse. Note the all-male jury seated at right. The nature of the trial is unknown, but it has created considerable interest. (Basil Clemons Photograph Collection, Special Collections, UT-Arlington Libraries.)

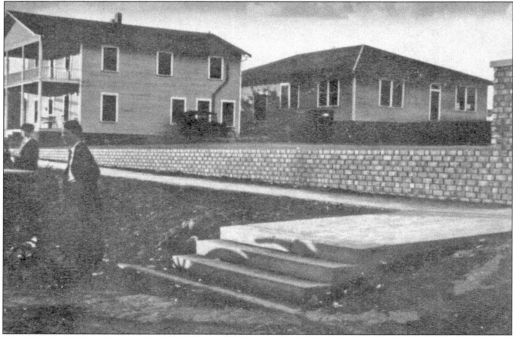

The "teacherages," located on Buckaroo Hill, used to provide housing for the teachers. These can be seen in the earlier snow scene southwest of the old high school. The one-story building behind the two-story one was used as the home economics classroom until the new cafeteria and home economics building was completed in 1958. (BISD.)

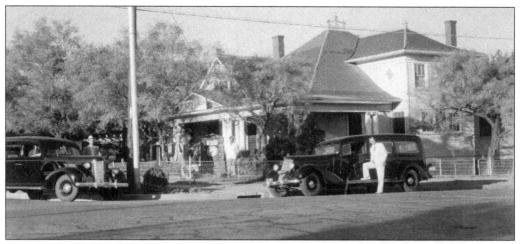

The home of Breck and Jo Alice Davis Walker, at the southeast corner of Walker and Miller Streets, is now First Methodist's parking lot. The Walkers moved to Fort Worth so their daughters could attend Texas Christian University, and the house became Thompson-Kiker's, then Kiker's, and then Melton's Funeral Home. M.P. Kiker stands to the left of the sign. (Basil Clemons Photograph Collection, Special Collections, UT-Arlington Libraries.)

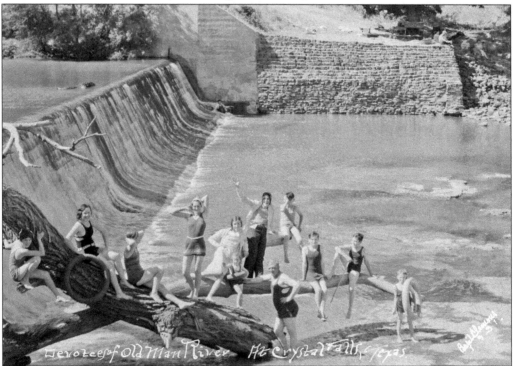

This great picture shows people swimming in the Clear Fork of the Brazos at Crystal Falls. The dam was built to capture water for Breckenridge's first water system. Joe Knight, his son, Joey, and Boyce Strong tragically drowned in the Clear Fork northeast of this site in 1962. The Little League baseball field was renamed in their honor. (Basil Clemons Photograph Collection, Special Collections, UT-Arlington Libraries.)

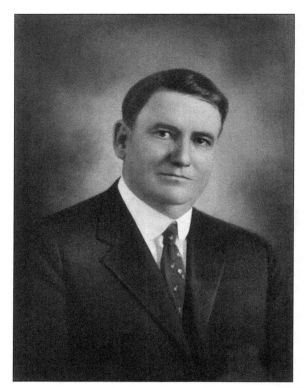

Breckenridge Stephens ("Breck" or B.S.) Walker (1876–1929) was a key figure in Breckenridge's early history. At one time before the Depression, it was reputed that his monthly income from his business ventures was $1 million. He partnered with Judge C.M. Caldwell to bring water and natural gas to the new booming town. (SMM.)

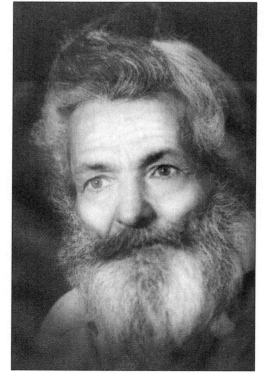

This Basil Clemons portrait is by a photographer named Morgan. Clemons arrived in Breckenridge at the beginning of the oil boom and recorded the people and places of the flourishing town, leaving a treasure of thousands of remarkable photographs capturing Breckenridge's history. His eyesight failed in the late 1940s, and he passed away in 1964. (SMM.)

Two

THE BOOM IS ON

It is undisputed that during the year 1920, Breckenridge grew from around 1,500 people to 30,000, growing by 10,000 in a single month. However, reliable figures or any consensus of how big Breckenridge got in the ensuing years are lacking. Published reports claim that it reached 50,000.

Oil production peaked in 1921 and then declined steeply. By 1925, over half the boom population was gone. By the 1930 census, the Depression had hit, the oil boom was over, and the population came in at 7,569.

Using the 1920 census, 30,000 people would have made Breckenridge the 11th largest city in Texas, just behind Austin. A population of 45,000 in 1920 would have made it the sixth largest city in Texas, behind only San Antonio (the largest at 161,379), Dallas, Houston, Fort Worth, and El Paso.

It is little wonder that the boom town, where everyone made good money, became a regular stopping point for circuses, Wild West shows, vaudeville acts, and other entertainments. Whatever its population, the pictures that follow show that it was a vibrant place.

Breckenridge was dry even before Prohibition. But there was no way to control 30,000-plus people, predominately young, unattached men out seeking their fortune and excitement in a town operating pretty much around the clock. Bootlegging, speakeasies, gambling, and ladies of the night were all prominent features.

Many lived in tents and other temporary structures. Beds were rented by the hour. At the Crystal Baths, men stood in line to pay $1.50 for a shower. The restroom was a quarter a visit. Jake Sandefer Jr.'s first sleeping quarters in the new boom town, in July 1920, was a cot behind the clerk's desk at the Commercial Hotel for $4 per eight-hour night.

For a time, Breckenridge had four railroads operating in and out of the city, two daily newspapers, 68 lawyers, 21 lumber companies, 88 hotels and rooming houses, and a post office that served 40,000 people. The Breckenridge fields were producing 50 million barrels of oil annually, more than produced by the entire state of Louisiana. The boom was on!

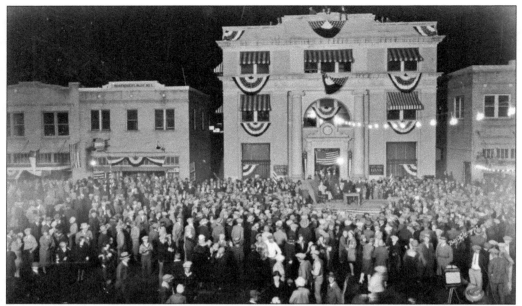

Organized in 1904, First National Bank survived multiple oil busts and the Depression and served Breckenridge until purchased by Texas American Bank in 1982. In October 1920, its three-story structure, now the Swenson Memorial Museum, was completed. In this April 4, 1926, photograph, Breck Walker is being sworn in as mayor in front of the bank of which he was president. (Basil Clemons Photograph Collection, Special Collections, UT-Arlington Libraries.)

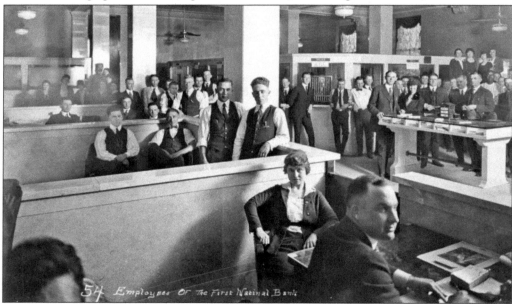

An interior shot shows the new First National Bank and its 54 employees ready to serve. The bank financed much of the drilling during the boom and had no meaningful competition until the founding of Citizens National Bank in the early 1960s. This building now houses the Swenson Memorial Museum. (Basil Clemons Photograph Collection, Special Collections, UT-Arlington Libraries.)

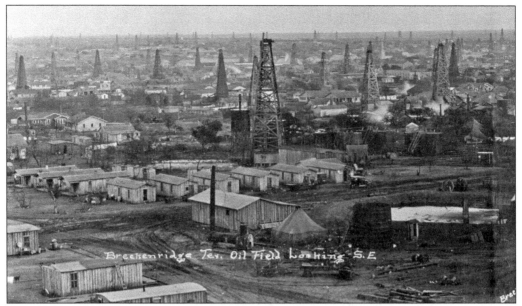

This 1920 view of the Breckenridge oil field was taken from approximately where the new gym and arts center is presently located. Only five percent of wells drilled in the 34-square-mile Breckenridge field were dry holes. A 1920 version of "man camps" is seen in the shotgun houses—one could shoot a shotgun from the front door through the back door without touching anything. (SMM-BCC.)

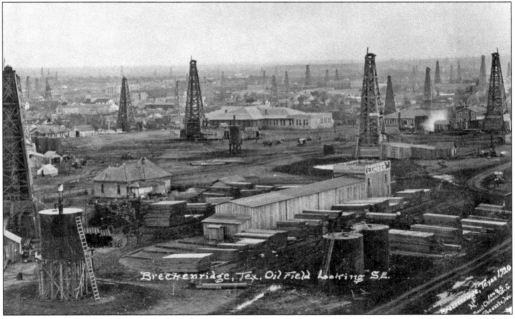

The other half of the oil field is seen here with wells dotting the city landscape. The long building at center is the 1910 school, located approximately where the present band hall and vocational and agriculture buildings are. The oil from the Breckenridge Field was of such high gravity it would run an automobile in its crude state. (SMM-BCC.)

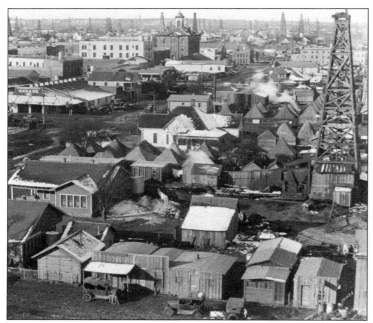

Looking southwest down Elm Street, note the tents crammed together in peoples' yards. Cheaply constructed box-and-strip shanties with roll roofing were used to quickly provide housing to the thousands flooding the town to be part of the boom. The Stephens County Garage is on the southwest corner of Baylor Avenue and East Elm Street, where Kime's Motors would later be located. (Basil Clemons Photograph Collection, Special Collections, UT-Arlington Libraries.)

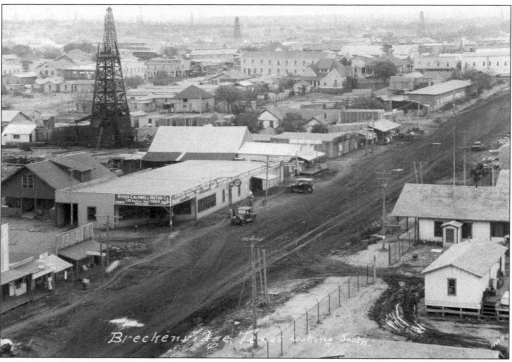

Looking southeast down Breckenridge Avenue, Byers Caldwell Motors is at 430 North Breckenridge Avenue. Note the numerous two-story frame hotels, slapped up fast and cheap to accommodate the booming population. Many of the buildings shown in pictures of this era disappeared not long after the boom went bust. (Basil Clemons Photograph Collection, Special Collections, UT-Arlington Libraries.)

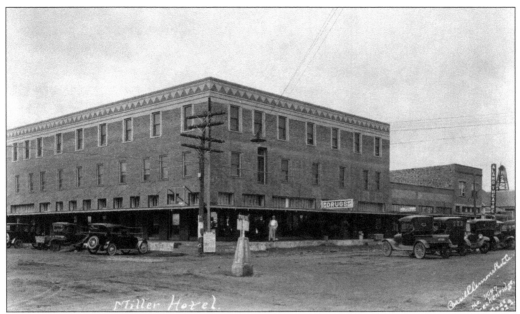

Construction of the 70-room Miller Hotel at 301 West Walker Street began in January 1920 and was completed the same year. One of the earlier masonry buildings in town, it also housed several shops and the Miller Coffee Shop, famous in later years for Leona's Mexican Enchiladas. It was torn down in 1964 to make room for the new Citizens National Bank. (Basil Clemons Photograph Collection, Special Collections, UT-Arlington Libraries.)

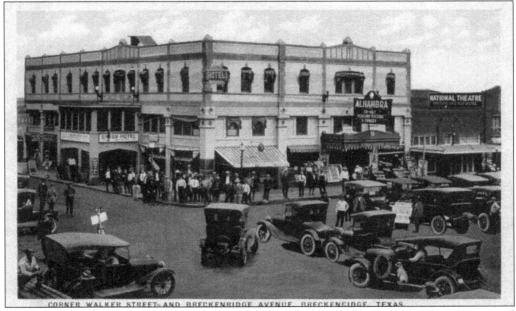

The Sager Hotel, on the northeast corner of Walker Street and Breckenridge Avenue, opened in 1920. It cost $180,000 and was plush when built. The more elegant Burch Hotel later stole its thunder as the elite hotel in town. The Sager was run by Sis Clark for many years and was razed in 1969. (Author.)

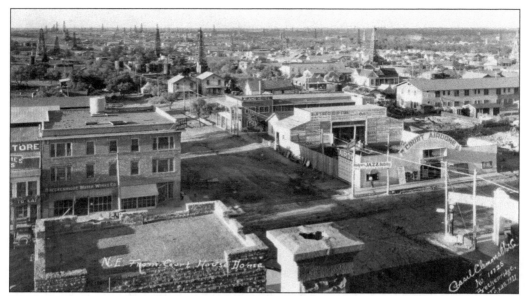

This view looking northwest from the old courthouse dome shows oil derricks dotting the landscape. The Airdome, which had a covered stage but open seating, hosted boxing and wrestling matches and other live entertainment and is located where city hall would soon be built. Hotel Pearson, which would later become Mobley Hotel and the Medical Arts Clinic, is on the northwest corner of Court and West Elm Streets. (Basil Clemons Photograph Collection, Special Collections, UT-Arlington Libraries.)

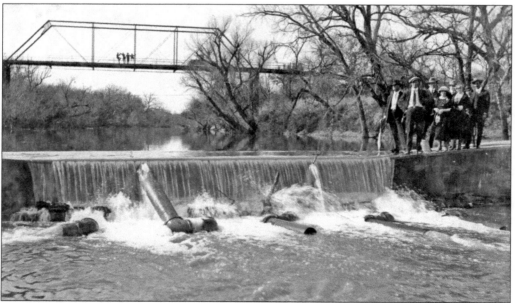

Walker-Caldwell Water Company built a dam at Crystal Falls on the Clear Fork of the Brazos River, some 10 miles north of town, and built a pipeline to serve the booming city. This is a close-up of its main water supply. Before this, most water came from underground cisterns, and some came from the Gonsolus Creek. (Basil Clemons Photograph Collection, Special Collections, UT-Arlington Libraries.)

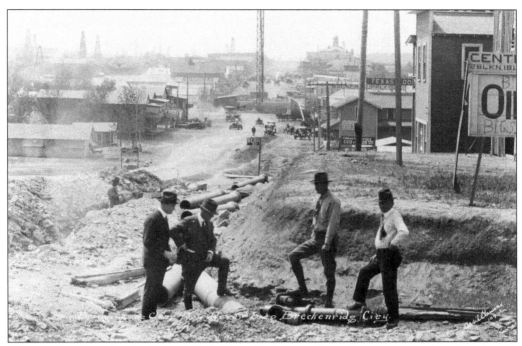

The pipeline brought the Crystal Falls Clear Fork water from the treatment plant into homes and businesses. This picture was taken looking west down the hill on a dirt East Walker Street. The tower in the middle of the road appears to be in use to build the viaduct over the Gonsolus Creek. (Basil Clemons Photograph Collection, Special Collections, UT-Arlington Libraries.)

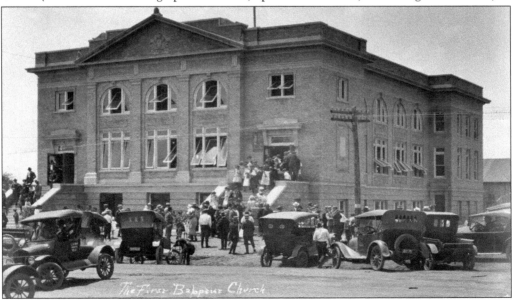

In 1921, a contract was let to build the present three-story brick First Baptist Church structure for $110,000. The first services were held on January 15, 1922, the date of this picture. A sharp drop in oil prices left the church in debt for a time, but the fully paid-for building was dedicated on June 13, 1926. (Basil Clemons Photograph Collection, Special Collections, UT-Arlington Libraries.)

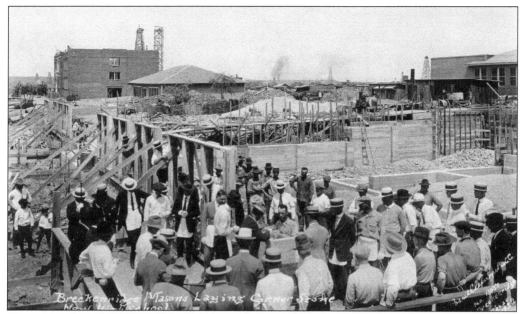

Clemons captured this 1922 Masonic ceremony setting the cornerstone of the new high school. Note that the construction of the Central Ward School, which later became the junior high, is in progress. The new high school was completed in time for the 1922–1923 school year as the local leaders scrambled to accommodate the booming population. (BA.)

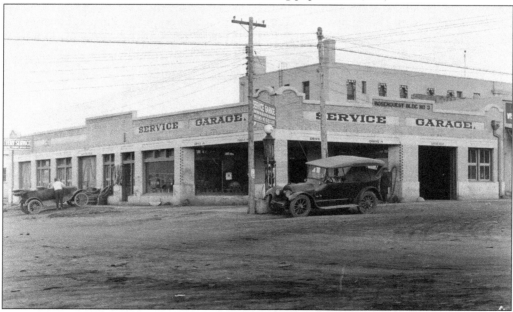

This is a 1922 picture of Service Garage on the southeast corner of Court and West Elm Streets, across from city hall. This building later housed the Breckenridge Water Company and Texas Louisiana Power Company. Many readers will remember this as Anderson's Appliance store and meat locker. This building was razed in 2015. (Basil Clemons Photograph Collection, Special Collections, UT-Arlington Libraries.)

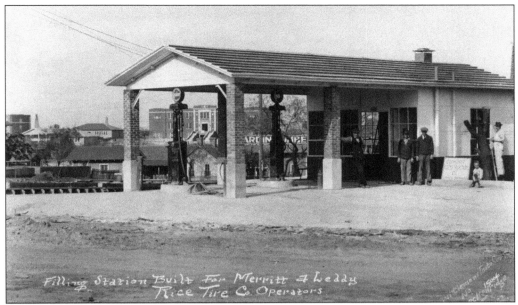

This 1922 photograph shows a nearly completed service station with the then-new high school in the background. Located on the northeast corner of McAmis Avenue and Walker Street, this station was for many years a Conoco service station run by "Fats" Magness. Magness, often sitting in a chair outside the station, is remembered about as well as the station. (Basil Clemons Photograph Collection, Special Collections, UT-Arlington Libraries.)

Pictured is the original Sacred Heart Catholic Church and rectory on the northwest corner of Hullum and Miller Streets. The church, built for $10,000, was blessed on June 3, 1923. Shortly thereafter, the rectory (which still stands) was built next door for $12,000. The present Catholic church was completed in 1961, and the pictured church, with its steeple removed, was relocated behind the new church as a parish hall. (Basil Clemons Photograph Collection, Special Collections, UT-Arlington Libraries.)

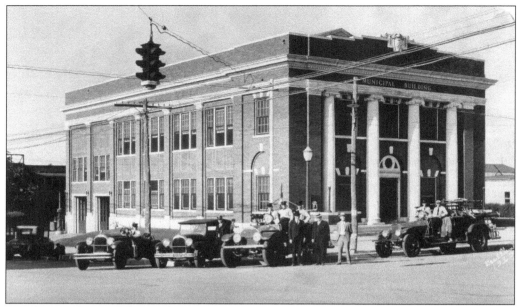

David S. Castle, an Abilene architect who later designed the new courthouse and the Burch Hotel, designed the new Municipal Building, which was completed in May 1922. Headlines blared that it would provide a city hall, fire station, library, and ladies' restroom "with provisions made for all conveniences in connection therewith." (SMM-BCC.)

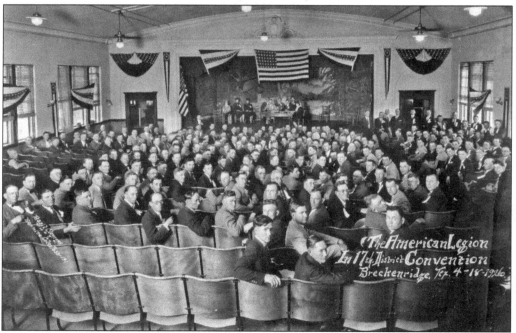

The prettiest feature of the new Municipal Building was the upstairs auditorium, pictured here, which seated 800, scaled back from the originally planned 1,000. Used for a time for revivals, boxing matches, conventions, and lyceums, its last use was apparently in the 1950s, and few people now know it exists. (SMM-BCC.)

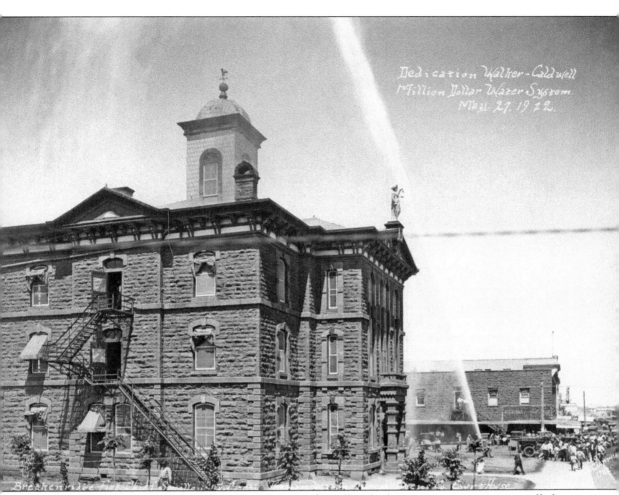

The May 27, 1922, dedication of Breckenridge's new $1-million high-pressure water system installed by Walker-Caldwell Water Company is pictured here. The availability of now-plentiful water was celebrated by shooting a stream of water above the spire of the three-story 1883 courthouse. A large cistern was buried behind this courthouse that caught water off its roof and was the primary water source of pre-boom Breckenridge. A 10-foot-by-15-foot outhouse was behind the courthouse for sanitation purposes. This courthouse and its jail and other outbuildings were torn down in 1927 after completion of the new courthouse, which had the jail and sheriff's quarters on the fourth floor. The building to the right of the courthouse, on the northeast corner of Court and Walker Streets, may be the oldest full building still standing in Breckenridge, appearing in pictures going back at least to 1911. (Basil Clemons Photograph Collection, Special Collections, UT-Arlington Libraries.)

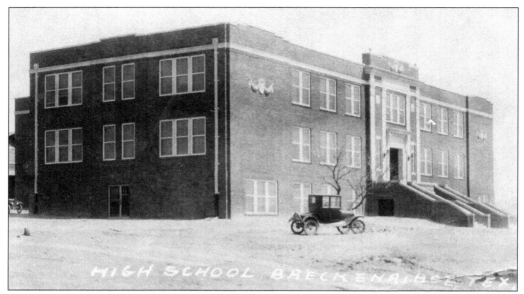

This beautiful three-story building with a grand auditorium served as the high school from 1922 until the present high school building was completed six weeks into the 1967–1968 school year. The auditorium remained in use until the building was demolished around 1978 to make room for the present auditorium. Junior high met here in 1967–1968 while the old junior high was demolished and replaced. (Author.)

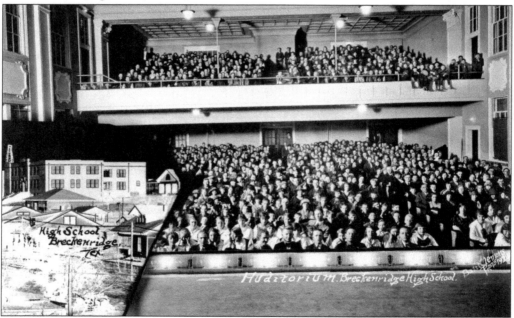

This 1923 photograph shows the interior of the packed Breckenridge High School auditorium from the stage. Both the lower and balcony levels are seen, and the inset at lower right shows the exterior, with the old school building behind it, which was then used as the cafeteria, band, and vocational building. Coronations, senior plays, graduations, and regular assemblies put the auditorium to good use. (Basil Clemons Photograph Collection, Special Collections, UT-Arlington Libraries.)

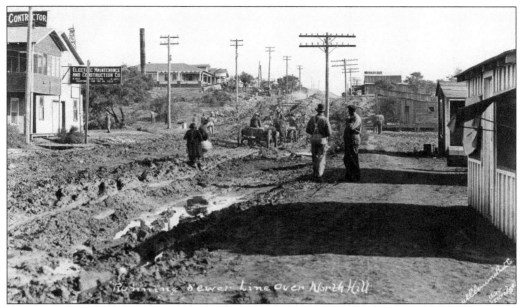

Streets in Breckenridge were impassable when rains turned the dirt to mud. Breckenridge experiences extended droughts, with Augusts often being particularly hot, dry, and brutal, but its rains often come in bunches, which turned its original dirt roads into a morass, as shown in this photograph of the sewer line being installed over North Hill on Breckenridge Avenue. (Basil Clemons Photograph Collection, Special Collections, UT-Arlington Libraries.)

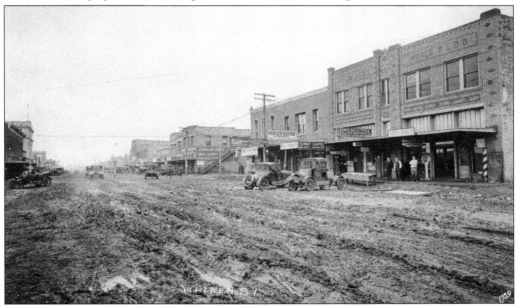

The east end of the 200 block of West Walker Street is in the mud in 1921. The Pierce Building housed, among others, Merrill's, White's Auto, Mode O Day, and Ellen's, a dress shop. The Miller Building was Henry Nahm's for a time, and the east end of that block was Woolworth's 5&10 and then Perry's 5&10. (Basil Clemons Photograph Collection, Special Collections, UT-Arlington Libraries.)

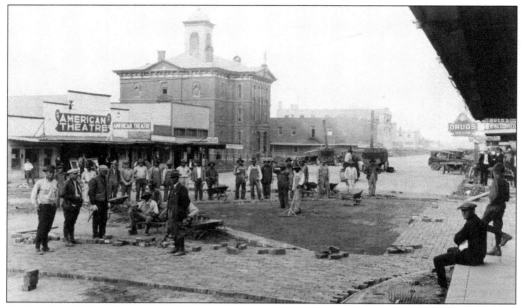

The new brick streets are being installed on April 5, 1923, beginning at the corner of Rose Avenue and Walker Street in front of the Miller Hotel. These iconic brick streets were removed and re-laid in 2004 with brick-like pavers along the edge, with the project paid for by grant money. Thoroughfares running east and west are streets, and those running north and south are avenues. (Basil Clemons Photograph Collection, Special Collections, UT-Arlington Libraries.)

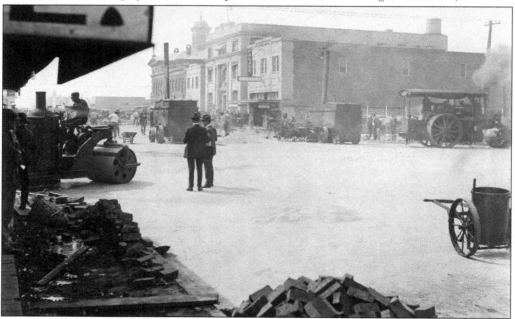

Another picture shows the men and interesting equipment installing the brick streets in downtown Breckenridge in 1923. This view was taken looking west from just east of the intersection of Breckenridge Avenue and Walker Street. (Basil Clemons Photograph Collection, Special Collections, UT-Arlington Libraries.)

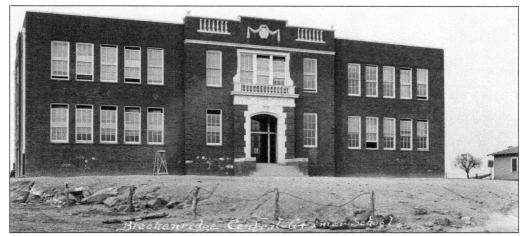

The Central Grammar School was constructed at the same time as the new high school and first used during the 1922–1923 school year. In the fall of 1925, it was reported that there were 936 students in Central Ward in a building designed for 438. This building was expanded and converted to junior high (grades six through eight) when North Ward was built in 1926. It was demolished in 1968. (Basil Clemons Photograph Collection, Special Collections, UT-Arlington Libraries.)

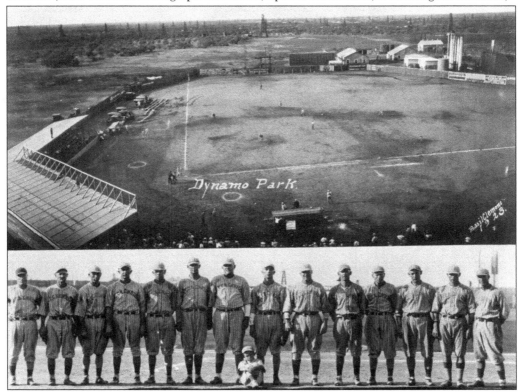

The Dynamos, at times a Class D minor-league club, represented Breckenridge in the national pastime of baseball. The Dynamo Ball Park was located at the Oil Belt Fairgrounds. The fences apparently moved around in front of its covered grandstand to create a multipurpose venue for air, auto, and motorcycle races, plus baseball and football games. (SMM-BCC.)

The first elementary school not on School Hill was completed in 1923. Sometimes called Walker Caldwell School, it was better known as East Ward. Few people elsewhere attended ward schools, which seems to connote a place whose patrons needed to be locked up. This three-story structure burned down on the night of October 28, 1959, with much of the town watching. (SMM-BCC.)

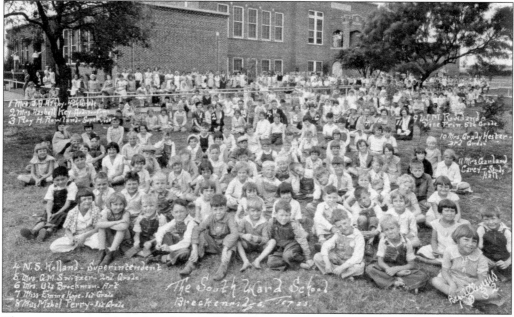

The two-story central portion of South Ward Elementary was completed in 1923. When growth made North Ward necessary, two two-room wings were added for the 1926 school year to make it approximately the same size as the new North Ward and also to support the original building, which was already showing cracks and would eventually be condemned mid–school year. (SMM-BCC.)

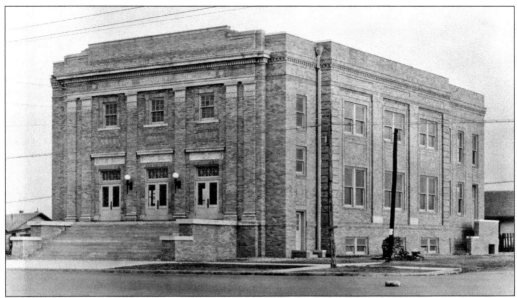

This 1924 picture shows the stately First Methodist Church on the southeast corner of Miller and Walker Streets. It was completed in 1923 and used until demolished to make room for the present church at the same location, which was completed in 1966. This replaced the frame structure directly across the street, which was then sold to the Church of Christ. (Basil Clemons Photograph Collection, Special Collections, UT-Arlington Libraries.)

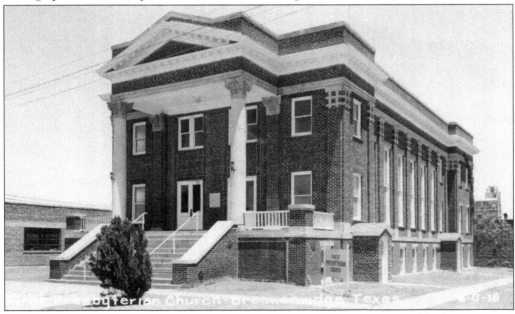

The First Presbyterian Church was built on the northeast corner of McAmis and Williams Streets. The first services were held on Sunday, September 30, 1923. It was built at a cost of between $30,000 and 40,000. This was used until the new church on West Elliot Street was completed in 1962. It was demolished and turned into a parking lot and then Gibson's Discount Center. Now InterBank, formerly Citizens National Bank, occupies the space. (Author.)

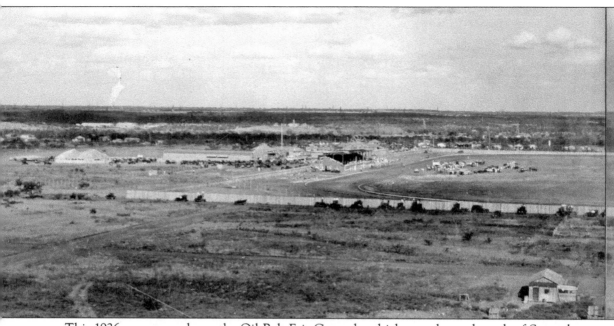

This 1926 panorama shows the Oil Belt Fair Grounds, which were located north of Seventh Street and west of Highway 183, where the baseball fields and armory were later located. The original two-story North Ward School can be seen to the right of the fenced-in track. The first Oil Belt Fair was held in 1925, and the fairs continued into the late 1930s. The original three-

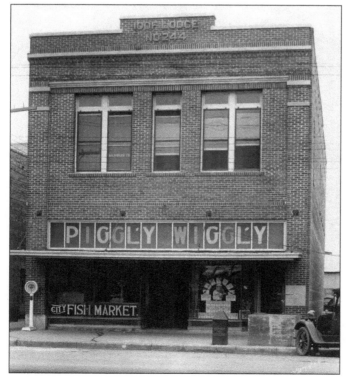

Presently the Sandefer Annex to the Swenson Museum in the 100 block of North Breckenridge Avenue, the Odd Fellows used the upstairs lodge and rented out the downstairs of this building to tenants such as the Piggly Wiggly store pictured here, one of two Piggly Wiggly stores operating in Breckenridge at this time. (Basil Clemons Photograph Collection, Special Collections, UT-Arlington Libraries.)

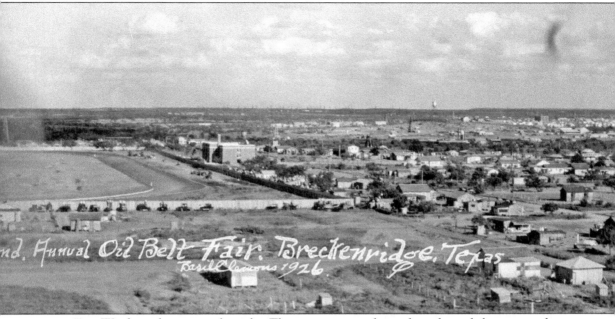

story East Ward can be seen at far right. There were covered grandstands, and these grounds hosted many circuses, Wild West shows, fairs, and other entertainments that made regular stops in Breckenridge during the boom times. There are pavilions to the left of the grandstand. (Basil Clemons Photograph Collection, Special Collections, UT-Arlington Libraries.)

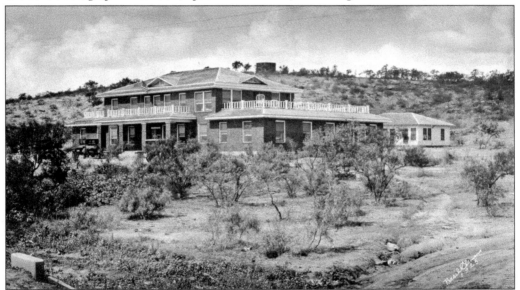

This is a 1925 picture of Westside Hospital, located on West Walker Street up the hillside behind the present Sonic. Hollywood stuntman and Olympic gold medalist Dean Smith was born here on January 15, 1932. It was also known as Breckenridge Clinical Hospital for a time. By the late 1950s, after Stephens Memorial Hospital was established, this was converted to a nursing home. It was demolished in the 1980s. (Basil Clemons Photograph Collection, Special Collections, UT-Arlington Libraries.)

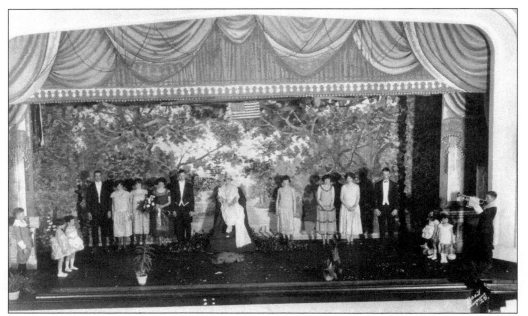

Ruth Stout is the Buckaroo Queen in this 1925 coronation. For fans of fairy tales, Breckenridge was the place to be. Most Popular, Class Favorite, and other superlatives also secured a slot in the queen's court and were solemnly announced as lords and ladies who, beginning in 1943, regally strode down a runway the length of the auditorium. (Basil Clemons Photograph Collection, Special Collections, UT-Arlington Libraries.)

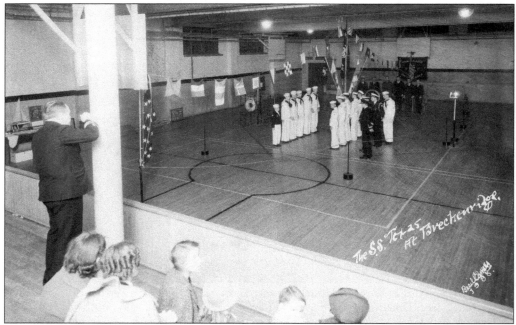

A Sea Scouts activity is included here to showcase the claustrophobic, low-ceilinged basement gym in the old high school. Sea Scouts are an organization focused on boating and water-based activities. (Basil Clemons Photograph Collection, Special Collections, UT-Arlington Libraries.)

Three

BRECKENRIDGE GROWS UP

When the boom started, the dirt streets were impassable when it rained. Water came from cisterns (and was poor quality), and the existing supply was inadequate for the booming town. Infrastructure was desperately needed. Several fires in the early 1920s burned swathes of frame structures downtown.

Locals stepped in to rebuild the town, and much of their handiwork remains today, 90 years later. A private enterprise, the Walker-Caldwell Water Company, built a water system for the new city and operated it until turning it over to the City of Breckenridge in 1928. Walker-Caldwell Production, owned by the same partners, built a natural gas system for the new city that also powered the drilling of wells during the boom.

Concrete streets, curbs, and sidewalks were built along parts of West Lindsey Street, South Shelton Avenue, West Williams Street, Hullum Street, Rose Avenue, Elm Street, East Connell Street, and other locations that remain in service today, seemingly without any repairs or remedial work having been performed in the 90-plus elapsed years.

The Municipal Building and fire station, the present city hall, was built. Walker Street downtown was paved with brick. The rest of Walker Street was paved, and part of West Walker Street, for a short period, was a boulevard. Walker Street became part of the North Loop of Highway 80, the Bankhead Highway, which then became US Highway 180.

Breckenridge got all new schools and a new courthouse in the 1920s. It got new churches funded by the oil boom, and it got its much-used and beloved YMCA.

Except where destroyed by fires over the years and a few demolitions, the downtown of the 1920s still stands, albeit with modifications over the years, including the mostly regrettable metal-siding storefronts of the 1960s and 1970s, many of which have since been removed.

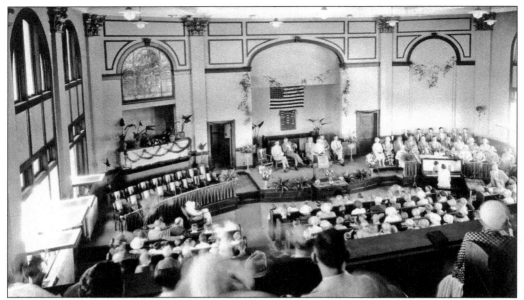

This is an interior shot of the dedication of First Baptist Church on June 13, 1926. Although completed and put into service in 1922, the grand church was not dedicated until it was paid for four years later. In 1958, a heating and air-conditioning system was installed. The interior of this church was restored in time for Easter Sunday 2015. (Basil Clemons Photograph Collection, Special Collections, UT-Arlington Libraries.)

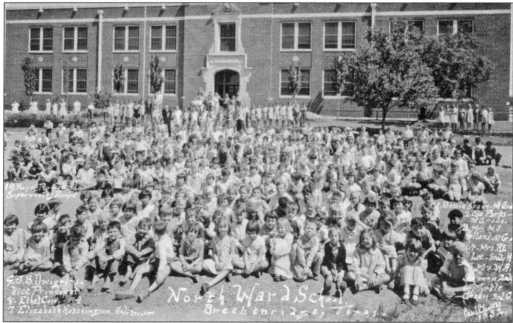

North Ward was completed in 1926. Its second story was condemned in the late 1950s, and a new building to house grades one through three was built to the east and completed in the fall of 1959, after which the second story was removed. The first story continued to be used for grades four through six. (SMM-BCC.)

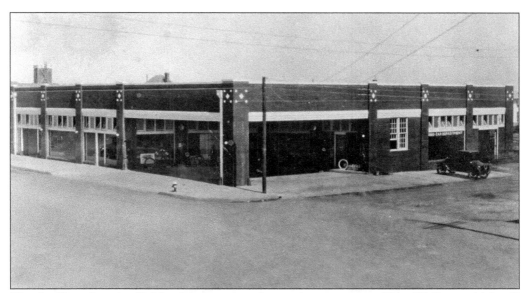

This building, housing Robbin-Mason, is on the northwest corner of East Walker and Merrill Streets. For many years, the eastern portion of this building was Giles Tire. For a short drag in the 1960s, one could turn around at the YMCA and cut through this drive instead of completing the drag all the way to the Anchor Drive-In. The building is presently Clay's Tires. (Basil Clemons Photograph Collection, Special Collections, UT-Arlington Libraries.)

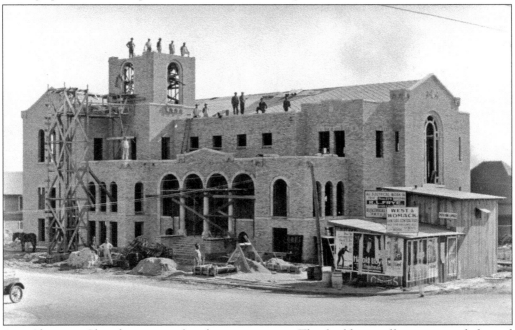

First Christian Church is pictured under construction. This building, still in use, was dedicated March 21, 1926. The edifice cost $110,000. Mayor B.S. and Jo Alice Davis Walker donated a $15,000 pipe organ in honor of their daughter, Gladys; it was reputed to be the finest organ between Fort Worth and Denver. The then-recently completed YMCA had cost $130,000. (Basil Clemons Photograph Collection, Special Collections, UT-Arlington Libraries.)

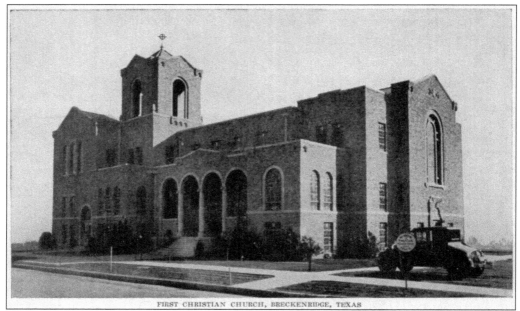

FIRST CHRISTIAN CHURCH, BRECKENRIDGE, TEXAS

This postcard shows the complete First Christian Church before Highway 183 was rerouted from Rose Avenue, taking some of the west end of this property for the highway right of way. The building was completed with no debt. It is unusual for such a small town to have a Disciples of Christ congregation, but it has long been a flourishing church. (Author.)

This building was on the northwest corner of Walker Street and Rose Avenue. It burned down on January 6, 1957, destroying five businesses, including Ray Wood Gulf; Little Kitchen Café, operated by Veda Sorelle; and Truett Carter's barbershop. Its shell still stands, and the site was used for many years by Ridgeway Motors. (Basil Clemons Photograph Collection, Special Collections, UT-Arlington Libraries.)

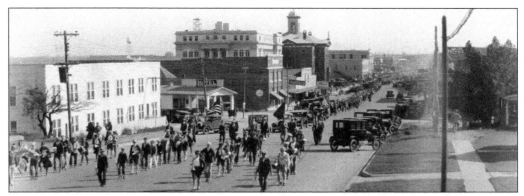

The old courthouse and the new courthouse are side by side in this rare picture. Note that the little café that became Nail's is not there yet. The two-story building across from the filling station was the Majestic Apartments. It was blown over by high winds in a storm in 1940 or 1941. (Basil Clemons Photograph Collection, Special Collections, UT-Arlington Libraries.)

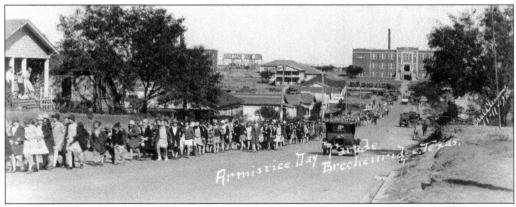

The 1926 Armistice Day parade makes its way up Miller Avenue with School Hill in the background. Note the skeleton of the old gym, which is under construction. The two-story teacherage, with the large porches, and the building behind it were used to board teachers for the schools. (Basil Clemons Photograph Collection, Special Collections, UT-Arlington Libraries.)

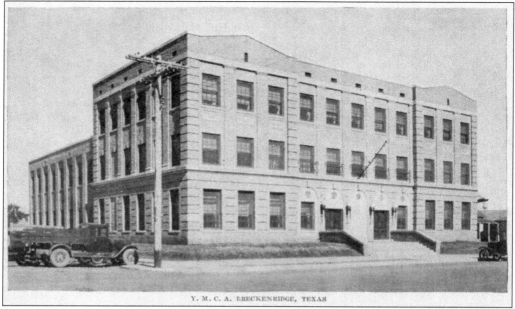

Y. M. C. A. BRECKENRIDGE, TEXAS

The YMCA was completed around 1926 at a cost of $130,000, paid for by subscriptions from approximately 900 people. A professional fundraiser was used. In March 1926, it had 1,100 members and separate lockers and lobby rooms for men and boys. Later there were boys' days and girls' days for swimming in the indoor pool where most local kids learned to swim. (Author.)

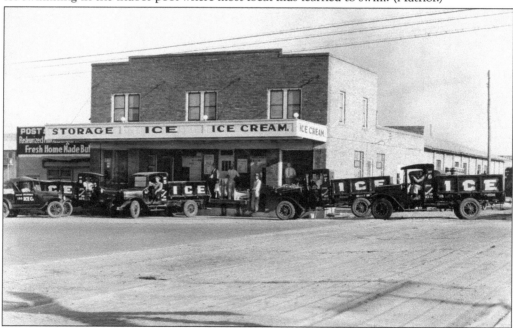

The Breckenridge Ice Company delivery trucks are ready to bring relief to a sweltering citizenry in the form of ice and ice cream. Breckenridge Ice, located approximately where J&J Electric is now, was one of two ice houses that were still operating in Breckenridge in the early 1960s. (Basil Clemons Photograph Collection, Special Collections, UT-Arlington Libraries.)

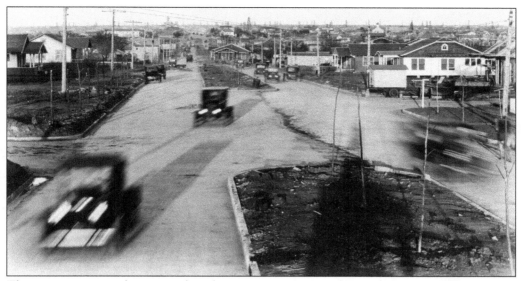

This picture proves the rumor that the city once attempted to make West Walker Street a boulevard. It must not have lasted long. Looking east from the Harvey Street intersection, the spire of the old courthouse is visible. As for another old rumor, the author is still looking for a picture, or even an artist's rendering, of the mythical electric paddling machine that was supposed to have been at the high school. (Basil Clemons Photograph Collection, Special Collections, UT-Arlington Libraries.)

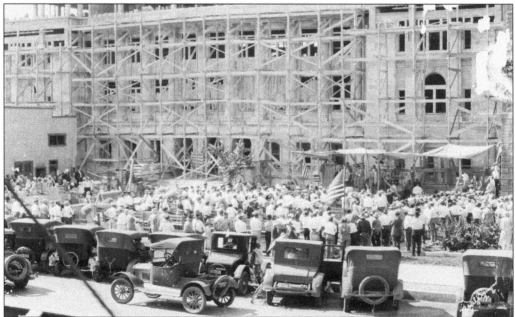

The new courthouse is seen here under construction. After a failed bond election in June 1924, Stephens County voters approved a new courthouse on January 10, 1925, the thriving town having outgrown the 1883 structure. Breckenridge voters approved the bonds by a four-to-one margin, barely overcoming the losing margin in the rest of the county. (Basil Clemons Photograph Collection, Special Collections, UT-Arlington Libraries.)

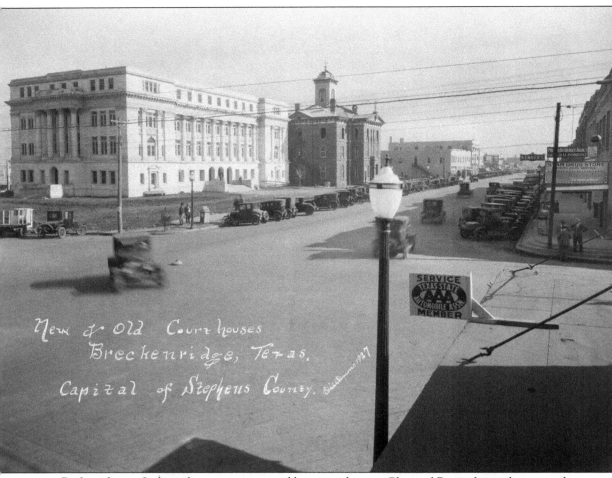

New & Old Court houses
Breckenridge, Texas,
Capital of Stephens County.

Built with gray Indiana limestone imported by train, the new Classical Revival courthouse, with its engaged Corinthian columns, is shown beside the 1883 courthouse it replaced. It cost in excess of $450,000 and was first occupied on December 27, 1926. The contractor claimed that the steel reinforcement in the new courthouse, placed end to end, could encircle the state of Texas and have some left over. Many believe the district courtroom to be the most beautiful in the state. (Basil Clemons Photograph Collection, Special Collections, UT-Arlington Libraries.)

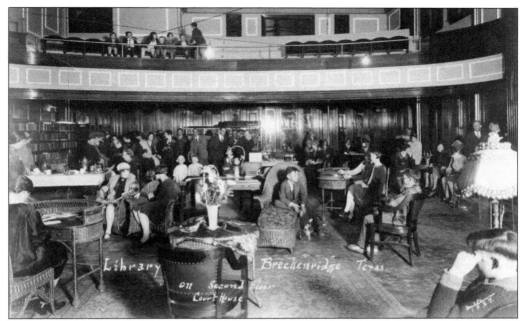

The courthouse featured twin courtrooms with balconies on each end of the second floor. The east courtroom, shown here, was initially used as a library. The district court moved from the west to the east courtroom in 1927. The west courtroom has been mostly ruined from flooding caused by unruly inmates in the jail above it and has been out of use for decades. (SMM-BCC.)

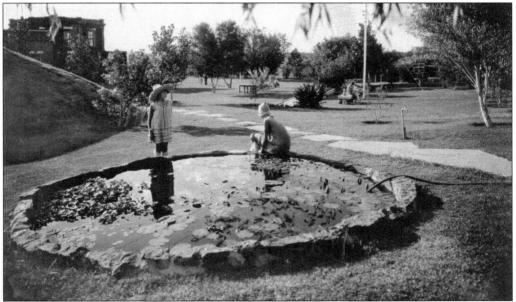

In this 1929 picture, people are enjoying the lushly landscaped Walker-Caldwell Water Park around its water plant (used by the city until 1975), another example of the civic mindedness of the Walker-Caldwell group. At one time, Walker-Caldwell Water Park included a small zoo, although it appears from pictures that its exhibits might have been indigenous animals such as mountain lions. (Basil Clemons Photograph Collection, Special Collections, UT-Arlington Libraries.)

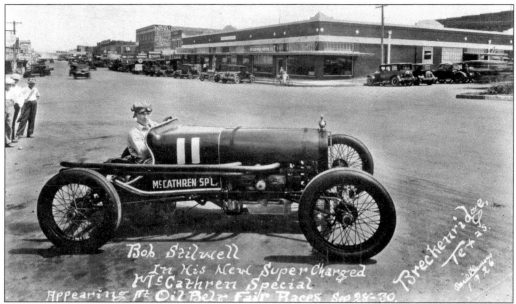

Races were held at the Oil Belt Fairgrounds. A race car is pictured here along with a great view of the long-since-demolished south side of the 300 block of West Walker Street. Ewing-Christian Hardware was later located on the west end. McCathern later relocated its Chrysler Motors dealership to the northeast corner of Rose Avenue and West Elm Street. (Basil Clemons Photograph Collection, Special Collections, UT-Arlington Libraries.)

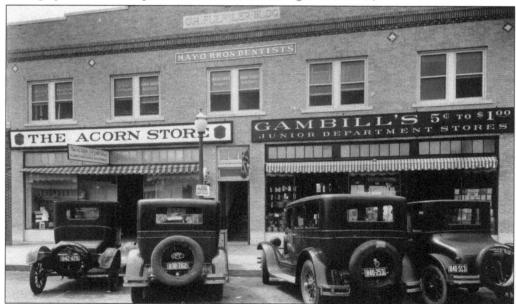

The Acorn Store and Gambill's 5&10 store occupied the Fulwiler Building, with Mayo Bros Dentists upstairs. The building still stands with the Fulwiler name visible. KSTB radio was later located upstairs, with "KSTB" and "Miller Building" painted on the side. Community Public Service and White's Auto were downstairs at one time, and still later, Montgomery Ward's occupied a portion of the downstairs. (Basil Clemons Photograph Collection, Special Collections, UT-Arlington Libraries.)

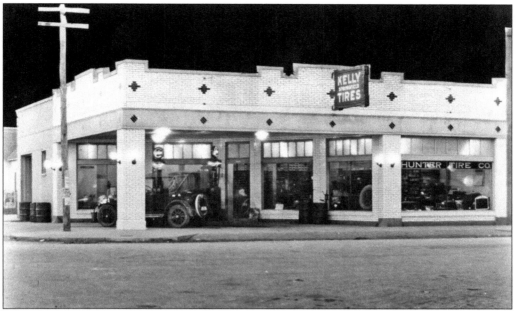

This drive-through station, one of many in town, was located on the northeast corner of Baylor Avenue and Walker Street, the present location of the Cook Building. Hunter Tire is the occupant in this picture. A service station operated in this building for many years, as will be seen in multiple photographs in this volume. (Basil Clemons Photograph Collection, Special Collections, UT-Arlington Libraries.)

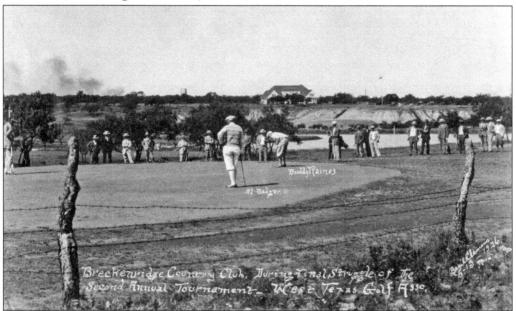

Al Badger won the West Texas amateur championship in 1926 at the Breckenridge Country Club, and Buddy Raines, pictured as well, won in 1927. This tourney continues and has been won by successful golfers such as Charles Coody and Jeff Mitchell. Boscar Satterwhite and Paul Blackerby are some of the outstanding golfers who have called this their home course. (SMM-BCC.)

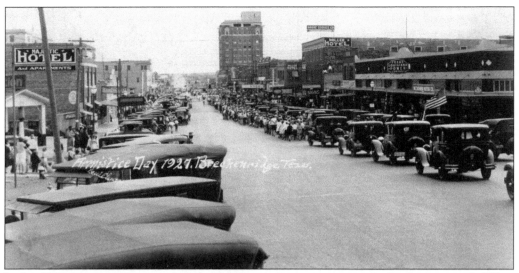

In this 1927 Armistice Day parade shot, the old courthouse is gone except for the entry arch. What would later become Nail's Café is now there, albeit only the front part before two expansions. To the right is McCathern Motors, which later became Ewing Christian Hardware, the electric company, and the Miller Hotel. (Basil Clemons Photograph Collection, Special Collections, UT-Arlington Libraries.)

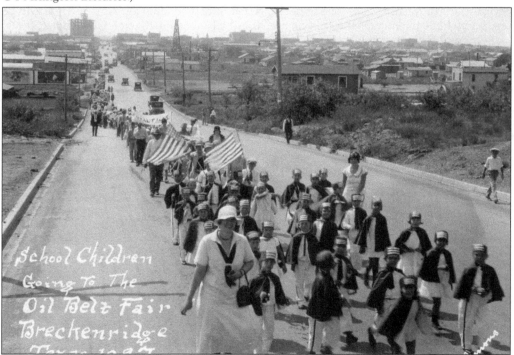

Schoolchildren in uniforms and teachers from all over Stephens County are marching up the hill on North Breckenridge Avenue to the Oil Belt Fair in 1927. The Crystal Falls schools are in the front. The Burch Hotel is under construction in the background. (Basil Clemons Photograph Collection, Special Collections, UT-Arlington Libraries.)

Early recycling efforts saw the sandstone from the old courthouse repurposed to build a new Assembly of God church. This structure, with the stone long ago painted white and a new roof and additions, still stands on North Breckenridge Avenue and is now Light of the World Christian Church. (SMM-BCC.)

This building, on the southeast corner of Walker and Merrill Streets, south of the YMCA, still stands and is being used. At the time of the picture, it was a Hudson Essex dealership run by Daniel Motor Company and had the open, covered drive typical of service stations of the time. The building later became a Ford dealership run by Daniel Motor Company and then King Brown Ford. (Basil Clemons Photograph Collection, Special Collections, UT-Arlington Libraries.)

51

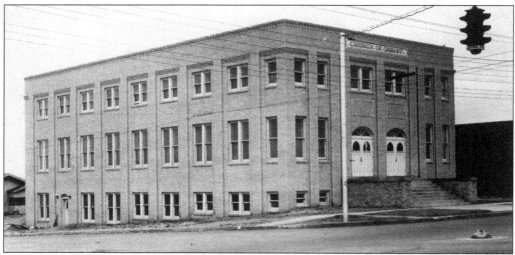

The first services in this new Walker Street Church of Christ building, located on the northeast corner of Miller and Walker Streets, were held on September 25, 1927. It was demolished after the present Church of Christ building was completed on West Elliott Street in 1970. Its basement had a Coke machine, and soft drinks were handed out at vacation Bible school instead of Kool-Aid. (Basil Clemons Photograph Collection, Special Collections, UT-Arlington Libraries.)

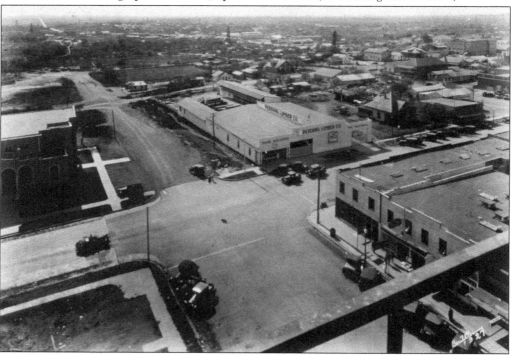

This aerial view shows Pickering Lumber on the southwest corner of Williams Street and South Breckenridge Avenue. Highway 183 came down Rose Avenue at this time and can be seen going over the hill in the distance. This location later became Higginbotham-Bartlett Lumber until it moved to West Walker Street. Crystal Baths was in the storefront second from the corner of Williams Street. (SMM-BCC.)

This steep-roofed service station, with additions, still stands to the east of the old railroad depot. To the right, Texas Tool & Supply is on the hill across from Miller Park. The filling station was a Mobil station operated by J.N. Browning into the 1970s. (Basil Clemons Photograph Collection, Special Collections, UT-Arlington Libraries.)

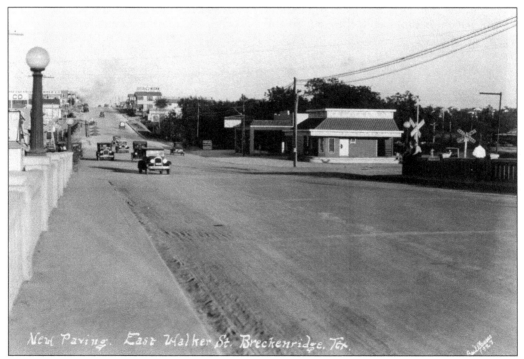

Piles of asphalt for the paving project can be seen on the hill looking east. Dillingham & Alexander Ice and Ice Cream, on the right, is located near the present entrance of Arthur Miller Park, east of the old railroad tracks and the viaduct across the Gonsolus Creek. (Basil Clemons Photograph Collection, Special Collections, UT-Arlington Libraries.)

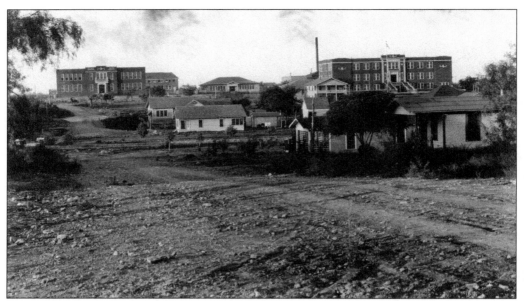

This c. 1926 view of School Hill looks down unpaved Smith Street. Central Grammar is to the left, the high school is to the right, and the gym is under construction. Apparently there is just a culvert under Smith Avenue for the creek at this point. Improvement of this creek was a New Deal works project in the 1930s, which is likely when the creek was widened and Lion's Park was completed. (Basil Clemons Photograph Collection, Special Collections, UT-Arlington Libraries.)

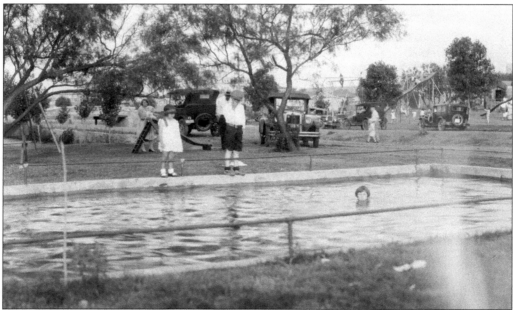

A swimming pool, playground equipment, and lush greenery can be found in Lion's Park, located along Walker Branch Creek between Live Oak and Miller Avenues. The familiar rock walking bridge across the creek near Smith Avenue can be seen through the trees as well as the courthouse, city hall, and the top of the Burch Hotel. This once-grand park was abandoned by the early 1950s. (Basil Clemons Photograph Collection, Special Collections, UT-Arlington Libraries.)

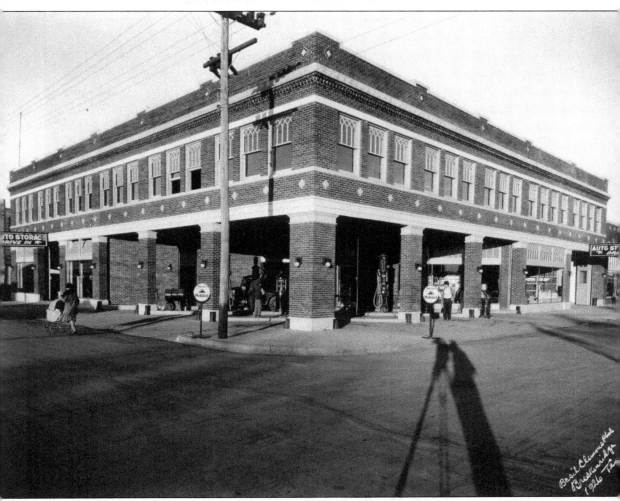

This building, and a handful of its beautiful windows, remains on the northeast corner of Williams Street and Rose Avenue. As built, it was one of the most impressive buildings in town. In the 1950s and early 1960s, it housed the Firestone store. It is now owned by R.E. Dye Manufacturing Inc. The east entrance off Williams Street featured a wooden ramp, still in use into the late 1960s, where vehicles could be driven upstairs and stored. Low-geared early vehicles likely navigated this easily, but more modern vehicles had to achieve the perfect speed—enough to get up the ramp but not so fast that one could not turn at the top before driving through the back wall. Davis Manufacturing, which assembled denim jeans a block away, used this upstairs space with its ramp for its shipping department for a time, making pickups and deliveries quite an adventure. (Basil Clemons Photograph Collection, Special Collections, UT-Arlington Libraries.)

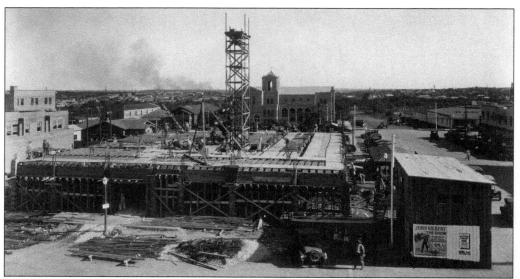

For years there had been talk of a grand hotel in Breckenridge. Plans were finally announced for a seven-story hotel on the southeast corner of Walker Street and Breckenridge Avenue, replacing several frame structures from the early oil boom such as the Cozy Rooms and Campbell Hotel. This picture shows the foundation and the rising elevator shaft for the long-dreamed-of hotel. (Basil Clemons Photograph Collection, Special Collections, UT-Arlington Libraries.)

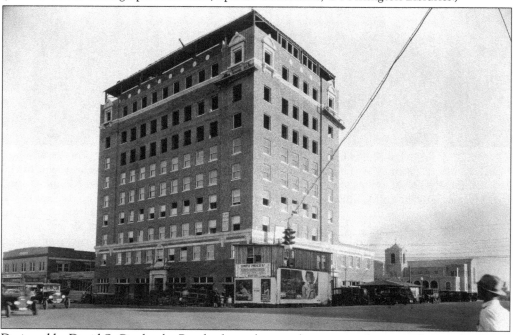

Designed by David S. Castle, the Burch, shown here under construction, grew during the design phase. The Elks Club wanted to add an eighth floor for its lodge. While under construction, local citizens got together to form a Petroleum Club and persuaded the owners to add a ninth floor to house it and a 10th floor for a rooftop garden, also owned by the Petroleum Club. (Basil Clemons Photograph Collection, Special Collections, UT-Arlington Libraries.)

Breckenridge citizens knew they were "home" when they saw the familiar Burch Hotel, which first came into view coming from the south on Highway 183 when they topped Five Mile Hill. It was designed as a blend of Spanish and Italian Renaissance architecture and watched over the rest of downtown. The Sager Hotel, to the left, was luxurious when built but could not compete with the new, lavish hotel. (Basil Clemons Photograph Collection, Special Collections, UT-Arlington Libraries.)

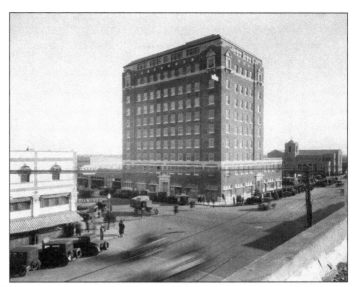

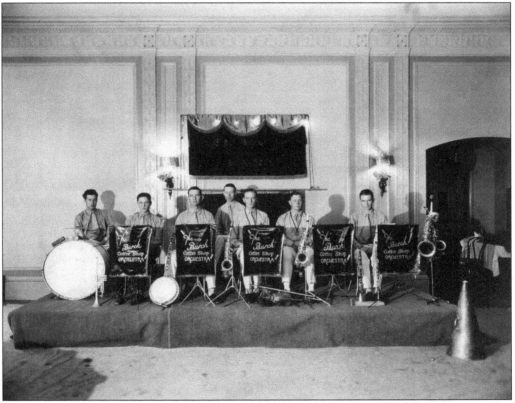

The Burch Coffee Shop endured into the late 1960s, but surely only during the pre-Depression boom days did it have an orchestra. The Burch opened for business on February 28, 1928, and it is reported that the guests danced all night. Dazzling balls were held in its two ballrooms with orchestras for dancing. This picture was presumably taken in one of the Burch's ballrooms. (SMM-BCC.)

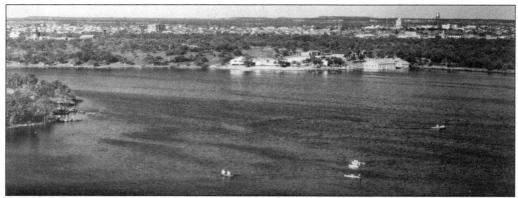

Lake Grand was located northeast of Breckenridge and was a major recreational area before it was ruined by salt water from nearby wells during the boom. This picture looks southwest from the lake into town, with the Burch Hotel in the distance and East Ward School on the left. (SMM-BCC.)

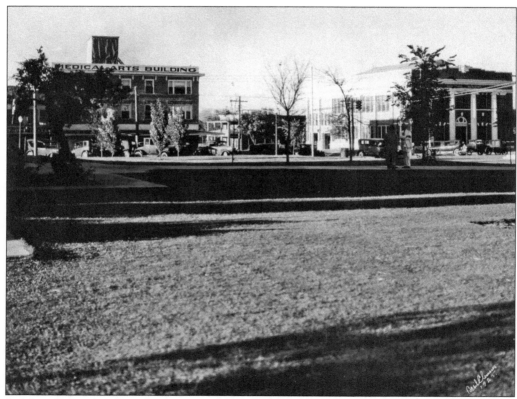

In May 1928, a doctor and investor purchased the three-story building at left on the northwest corner of West Elm and Court Streets, which was then the Mobley Hotel (identified in a 1921 picture as the Pearson Hotel), and converted it to the Medical Arts Building. It operated as a hospital into the mid-1950s, after which it was converted into apartments. (Basil Clemons Photograph Collection, Special Collections, UT-Arlington Libraries.)

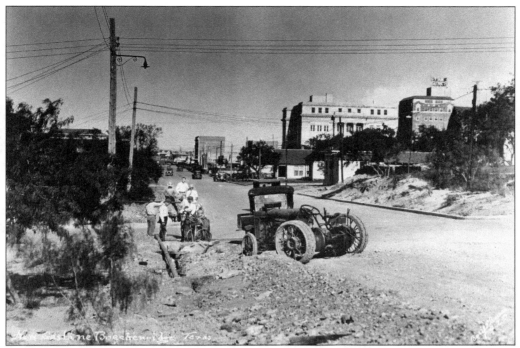

This view of downtown Breckenridge looks east down West Elm Street from just west of Miller Avenue, showing the installation of the new gas line in 1929. This line may very well still be in use. It is a less often seen view of town away from the main street but familiar to those who "rode shank's pony" (walked) to town from the northwest. (Basil Clemons Photograph Collection, Special Collections, UT-Arlington Libraries.)

This 1929 view looks northwest over downtown from behind the Burch. The ornate stone was used only on the north and west sides of the hotel. The building at lower right is the Texas headquarters of Phillips Petroleum, later the Elks lodge. The house to the left of Phillips was the office of Dr. H.H. Cartwright up until his retirement in the late 1960s. (Basil Clemons Photograph Collection, Special Collections, UT-Arlington Libraries.)

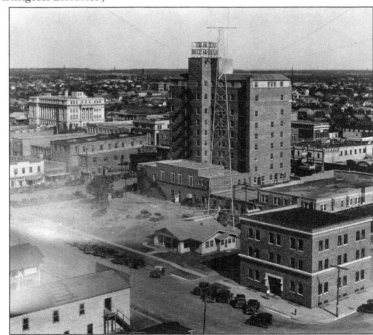

59

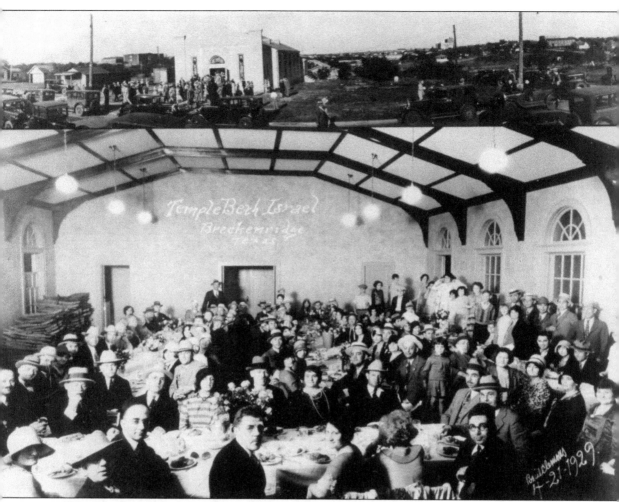

When the Temple Beth Israel Synagogue was completed in 1929, about 60 Jews lived in Breckenridge. Many stores owned by Jewish merchants can be seen in the pictures in this volume: Bender's Department Store, Winkler's, S. Segal, Louis Daichsman Jewelers, Oscar Glickman, and others. The Jewish population became an integral part of the community. Some moved on after the first oil boom subsided, but a sizeable number remained. The Popular, operated by the Socols and Shapiros, remained in business until the mid-1980s. The Bendorfs, whose son Robbie was student body president in 1962–1963, operated Breckenridge Oil Field Supply. Many Breckenridge kids were taught English at South Ward by the stern Tillie Tuck, wife of Al Tuck. Frams, Abramsons, Nahms, Kupermans, Cohens, and others were all part of the fabric of growing up in Breckenridge. While St. Andrews Episcopal Church was being built, the congregation used Temple Beth Israel for its services. After the last of the Jewish community left Breckenridge in the late 1980s, the synagogue was sold and the net proceeds donated to local charities. (SMM-BCC.)

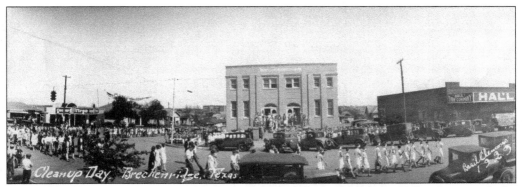

The 1929 Clean Up Day Parade makes the turn from Miller Avenue onto Walker Street with the Church of Christ in full view and Hall Tire to the right. (SMM-BCC.)

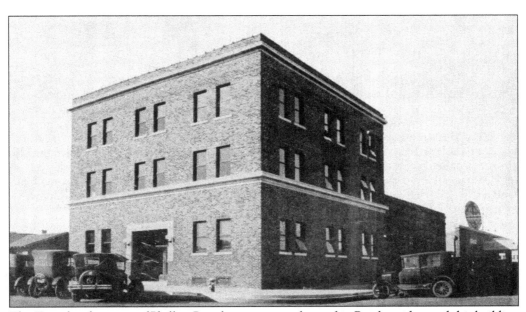

The Texas headquarters of Phillips Petroleum was once located in Breckenridge, and this building was constructed for that purpose. At some point, the Elks moved from the eighth floor of the Burch Hotel into this building on the corner of Williams Street and Baylor Avenue and remained there until moving west of town in the late 1970s. This building still stands. (Author.)

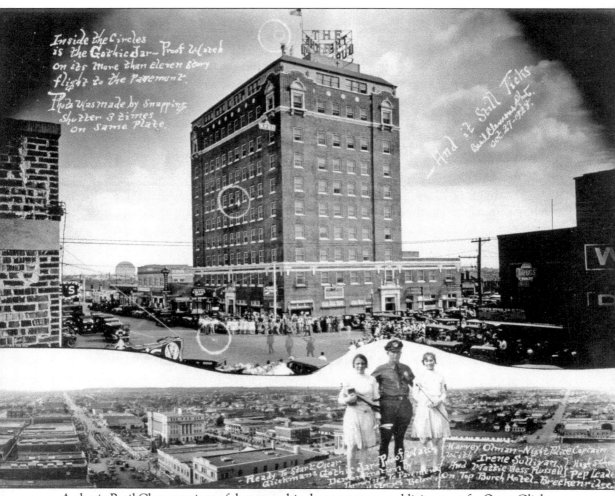

A classic Basil Clemons piece of showmanship demonstrates a publicity stunt for Oscar Glickman Jewelers' Gothic Jar-Proof Watch long before Timex's "It takes a licking and keeps on ticking." A watch was thrown by two pep leaders, escorted by a night police captain, more than 11 stories from atop the brand new Burch Hotel, with multiple exposures marking its progress. Clemons also provides a close-up of the activity at the top of the Burch Hotel and the view looking down from the skyscraper. He details on the picture how he captured the descent of the watch and proclaims "and it still ticks." This event is referenced in an extant 1928 advertisement in a football program for a game with Cisco. (SMM-BCC.)

Four

EARLY FOOTBALL PROWESS

Breckenridge began playing University Interscholastic League (UIL) football in 1922, playing in the Oil Belt Conference along with Abilene, Cisco, Eastland, and Ranger. Pete Shotwell, who coached Abilene to a state title in 1923, took the Breckenridge head coaching position in 1927. At a time when recruiting was legal, Boyce "Boone" Magness and his family (including brother Aubrey, who was also a standout player) were moved from Comanche, cow and all, on a flatbed truck by J.D. "Jake" Sandefer Jr. so he could play football.

The 1929 squad, led by Magness, one of the all-time great players in Texas schoolboy history, tied Port Arthur 0-0 in a state championship game played in Waco in a foot of snow with sleet also falling during the game. Port Arthur never got past its own 40-yard line. Breckenridge penetrated Port Arthur's 20-yard line five times in the first quarter alone and came within inches of scoring. It is the historical consensus that Breckenridge was the far superior team. Breckenridge asked for a rematch, which was permissible at the time, offering to play in Port Arthur on any date the opponent named, but Port Arthur wisely declined.

The 1929 squad outscored its opponents 330-24 en route to its 12-0-1 record. Four opponents managed to score six points each, one of those being Brownwood, which lost 59-6.

Pete Shotwell coached the Bucks from 1927 through 1934 and was replaced by Eck Curtis who, during his tenure from 1935 through 1944, competing against all comers, compiled an 83-22-6 record, winning seven district championships in 10 years. In 1942, he lost in the semifinals to the eventual state champion, Austin. His 1943 team scored 499 points and defeated Mineral Wells 103-0. Coach Curtis filmed his games, in color by 1938, and attended Pat Leahy's Notre Dame spring practices every year to get the latest ideas, all funded by the Quarterback Club.

Eck Curtis was replaced by Cooper Robbins, who remained through the 1951 state championship season. The Buckaroos and their battle cry "Fight 'Em Bucks" became feared statewide.

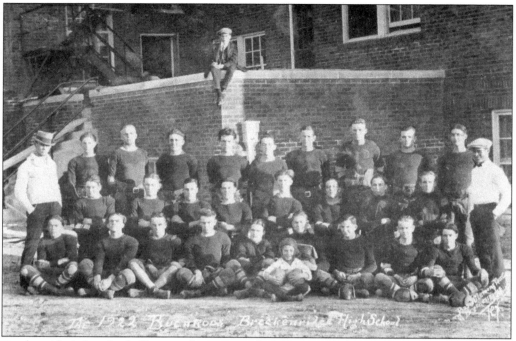

Breckenridge's first football team after joining the UIL compiled a 5-2 record in 1922. It played on a gravel-and-goat-head-sticker field, competing in the tough Oil Belt Conference with Cisco, Eastland, Ranger, and Abilene. Before high school football started, a group in town under the auspices of the American Legion Post organized a semi-pro football team named the Blinking Buzzards. (BISD.)

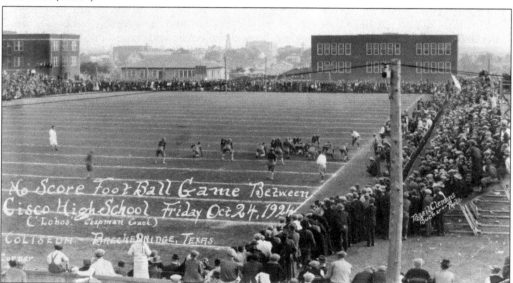

This 1924 game against Cisco ended scoreless. There is no gym to frame the south end of the field yet, so the Central Grammar (later junior high) is seen at the south end. Hash marks were not used yet, and play resumed from the spot the ball went dead, which is why the players are lined up against the west sideline in this photograph. (SMM-BCC.)

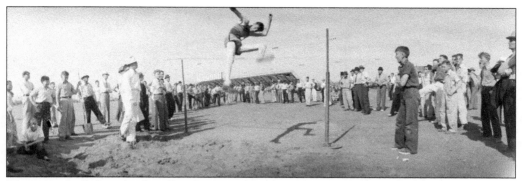

This picture is believed to be of Jim Stewart of Breckenridge who, under the tutelage of coach Bart Coan, won state in high jump in 1925 (6 feet, 2.125 inches) and also started as an end in football. The 1926 annual says he won the national high jump title in 1925 as well. For perspective, 6 feet, 2.665 inches was good for silver at the 1928 Olympics. Stewart competed collegiately at the University of Southern California. (Basil Clemons Photograph Collection, Special Collections, UT-Arlington Libraries.)

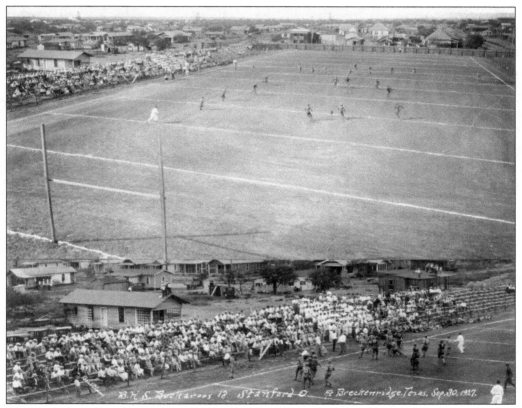

The Bucks beat Stanford 18-0 on September 27, 1927, at Buckaroo Field. In this picture, taken from the south end, the square two-story square on Second Street where people used to watch games from the roof is visible. The picture was taken before bleachers were built on the north end. This classic Clemons composite shows a close-up of the action at the bottom. (SMM-BCC.)

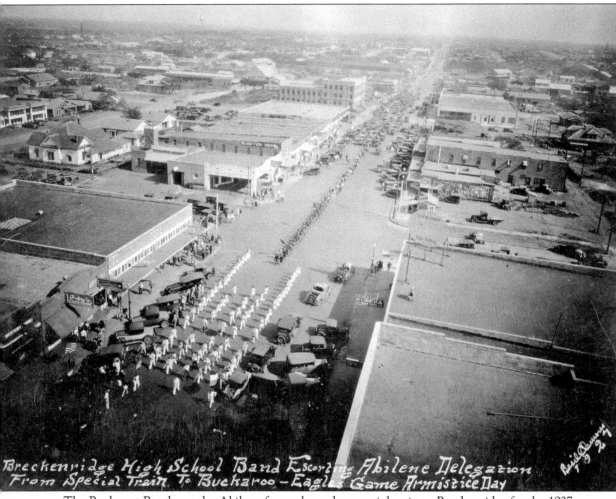

Breckenridge High School Band Escorting Abilene Delegation From Special Train To Buckaroo - Eagles Game Armistice Day

The Buckaroo Band met the Abilene fans, who rode a special train to Breckenridge for the 1927 Armistice Day game, and escorted them to the stadium, as shown in this intriguing picture. Community support for football in Breckenridge was remarkable. At one time, the captain of the football team was guaranteed a prestigious summer job at McArron's The Hub men's store. A town of 6,000 had a stadium that seated 8,500 by the 1930s and could accommodate 10,000 using standing room, but season tickets were perpetually sold out. This beautifully lit picture, taken from the under-construction Burch Hotel, gives a great view of East Walker Street. The south side of the 200 block of East Walker Street would soon be demolished and replaced with service stations. Note the station where the Cook Building now stands and the YMCA in the distance. (Basil Clemons Photograph Collection, Special Collections, UT-Arlington Libraries.)

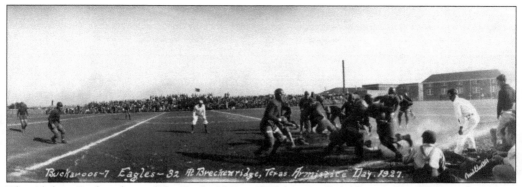

The Abilene Eagles whipped the Bucks 32-7 in 1927 despite all the hospitality. This picture shows an action shot of the game. Note that the newly constructed high school gym now anchors the south end of the stadium to give an enclosed bowl effect. (SMM-BCC.)

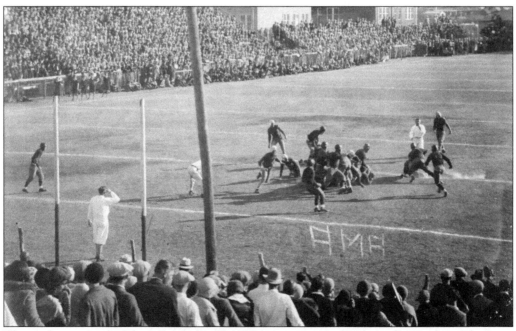

The stadium is packed for a December 7, 1929, game against the Amarillo Sandies. There are bleachers in both end zones and a standing-room crowd. Boyce "Boone" Magness ran 30 yards for one score and hit David Graham with a pass for the other score. Aubrey Magness kicked one extra point in the 13-0 victory. Boyce later played for Washington State University. (Basil Clemons Photograph Collection, Special Collections, UT-Arlington Libraries.)

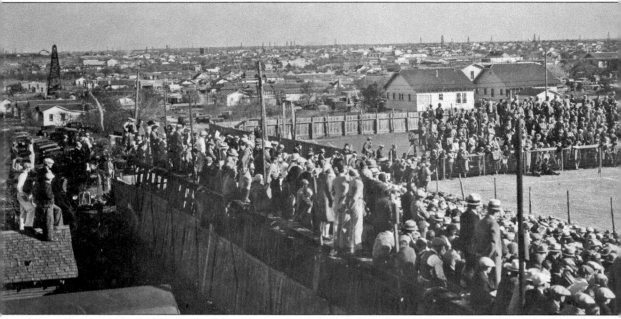

Breckenridge held a 7-6 lead in this game against Waco with just two minutes left and had the game won, but the betting spread favored the Bucks by six. Contrary to instructions, Boone Magness dropped back and hit Garland Carey with a perfect pass for a touchdown and the final 14-6 score. When Coach Shotwell asked Boone what came over him, he replied that everyone

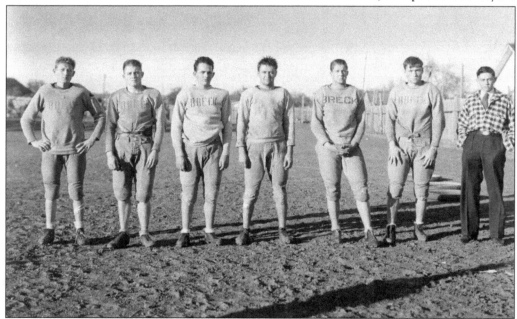

Breckenridge's Four Horsemen during its 1929 championship run are, starting third from left, Doyle Pruitt, fullback and blocker; Aubrey Magness, quarterback; David Graham, halfback and run, pass, and kick triple threat; and Boyce Magness, whose punting kept Port Arthur bottled up on its end of the field for most of the snow game. (SMM-BCC.)

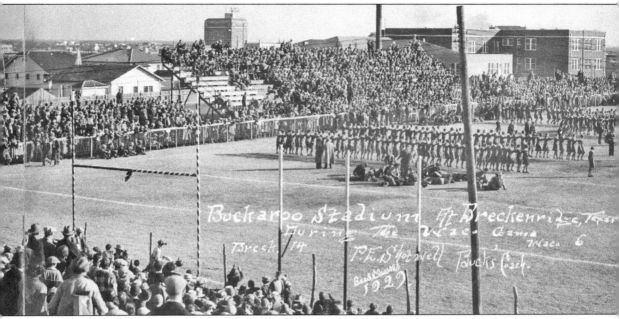

on the field had money on the game. It is said that this play resulted in a massive shift of money from Waco to Breckenridge. This was only the fifth loss for the legendary Paul Tyson's Waco squad in nine years. The game was played before more than 10,000 fans at Buckaroo Stadium. (Basil Clemons Photograph Collection, Special Collections, UT-Arlington Libraries.)

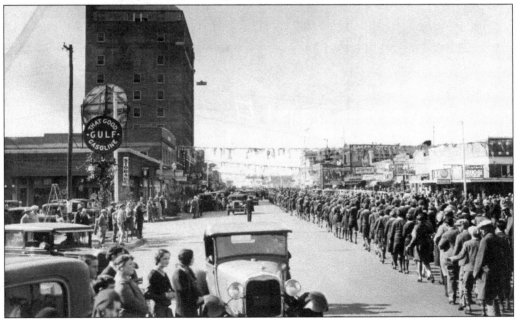

A massive downtown pep rally and parade (a longstanding Buckaroo tradition) is pictured before the December 7, 1929, quarterfinal game with Amarillo. Note the Christmas decorations and the monumental community support for the boys. (Basil Clemons Photograph Collection, Special Collections, UT-Arlington Libraries.)

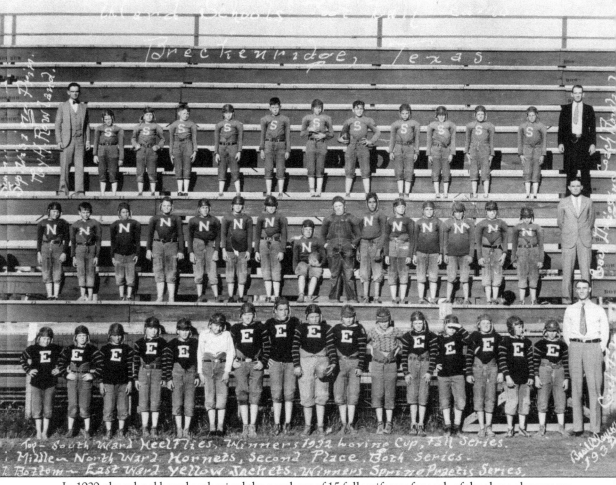

In 1929, the school board authorized the purchase of 15 full uniforms for each of the three elementary schools to initiate full-pad football against each other. North Ward and East Ward misplaced one uniform each. South Ward lacked the players to need all 15 so presumably supplied extra uniform components to the other schools. These squads played in the fall and had a spring practice series as well under the tutelage of paid coaches. The teams were the North Ward Hornets (later the Raiders), South Ward Heel Flies (later Wildcats), and East Ward Yellow Jackets. The first proposed name for South Ward School was Peek Ward, and then Southwest Ward, so the team could have been the Peek Ward Heel Flies. They played Monday nights at Buckaroo Stadium, cheered on by cheerleaders with unique sing-song cheers and watched by sizeable crowds evaluating the upcoming talent. The Quarterback Club, the local booster club, met Monday nights following the ward school games. (SMM-BCC.)

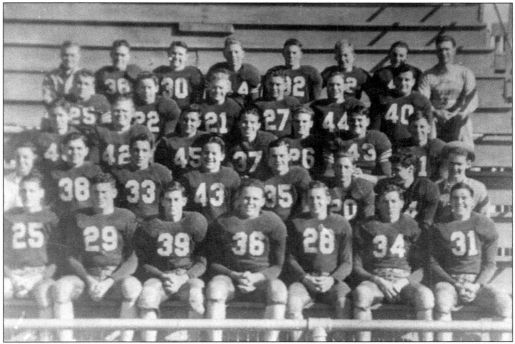

The 1943 team under Eck Curtis (top row, far left) beat Mineral Wells 103-0 and Abilene 53-0. The Buckaroos outscored their opponents 499-45, losing only to Fort Worth North Side 20-14 and tying Waco 13-13 in the playoffs, with Waco advancing on penetrations. Richard Rowan made All-State as left end, and Walter Minchew, Charlie Gallagher, Paul Campbell, Wesley Cox, and Quincy Corbett made All-District. (SMM.)

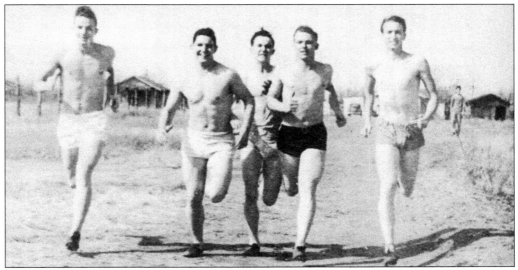

This picture from 1943 recalls the days (up until a track was built in the early 1960s) when they just ran a grader around the football field parking lot and called it a track, and "skins" was considered appropriate attire for the yearbook. Luther "Bugs" Fambro, practicing in a sand pit, won the large school state title in high jump in 1943 with a 6-foot, 1.25-inch mark. (BISD.)

Cooper Robbins coached the Buckaroos from 1945 through 1951, winning Breckenridge's first outright state title in 1951. He left to become an assistant coach at Texas A&M, taking his twin sons, Ronald and Donald, along to play with the Aggies. In 1954, he was joined at A&M by the legendary Bear Bryant, and Donald became one of Bryant's legendary Junction Boys. (BISD.)

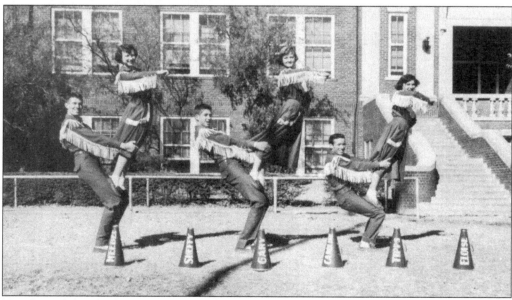

New fringed cheerleader uniforms were introduced for the 1949 season anticipating the phenomenal football of the 1950s. Community and student support factored heavily into the success. The Quarterback Club controlled the hiring of coaches, and 10 members pledged $100 a month each for years to get the coach what he needed to succeed. (BISD.)

Five

THE TOWN SETTLES IN

The Great Depression and the end of the oil boom ushered in a new era. The population of the newly built town constricted down to approximately what it has been ever since. It would take 36 years for Stephens County residents to pay for their grand Classical Revival courthouse. Breckenridge's centerpiece 10-story Burch Hotel remained, although its original owners were ruined financially. There was still the YMCA, paid for in full by subscription, with its gym and indoor swimming pool. There were sparkling new schools to educate the young, including the three neighborhood elementary schools that town kids could and did easily walk to in those simpler times.

The days of expansion and free-flowing money over, the core citizens dug in to make Breckenridge a fine place to live under the changed circumstances. The Depression segued into World War II, to which Breckenridge provided many of its youths. The 1943 Buckaroo annual, along with coverage of the high school activities, chronicled every serviceman from Breckenridge with nice-sized photographs and listings of accomplishments, exceeding the picture sizes for the graduating seniors.

As the war drew to a close, the Breckenridge that older residents remember took shape. The A&P moved to its new location at West Elm Street and Rose Avenue on October 22, 1945. C.R. Anthony and Co. opened on the northwest corner of Walker Street and Breckenridge Avenue on June 20, 1946. Also in 1946, Jake and Rae Sheinberg Socol purchased Burr's Store at 103 West Walker Street and changed its name to the Popular. In 1948, Lake Daniel, the new water supply for the town, filled up for the first time. The fall of 1949 saw the first direct-line, play-by-play coverage of away Buckaroo football games from the Corral Theater. A person with a telephone reported the game, which was broadcast on the loud speaker to theater patrons. Families who owned an extra car would park it during the day to reserve a spot.

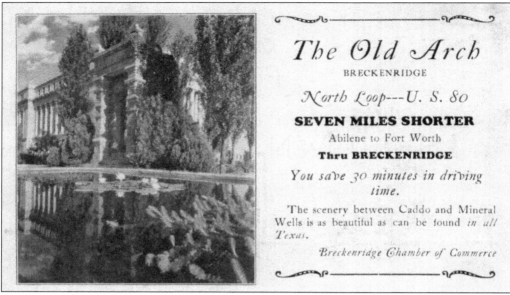

A picture of the old arch and the new courthouse is featured on this chamber of commerce card recommending taking the North Loop–US 80 (to become US Highway 180 later) to save seven miles and 30 minutes driving between Abilene and Fort Worth. This loop was an alternate route on the famous Bankhead Highway. (Author.)

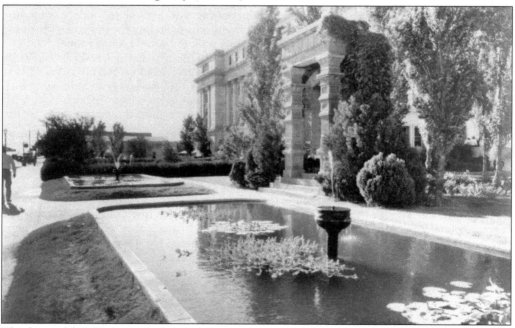

This beautiful 1931 photograph shows the stately new courthouse and the old entry arch from the 1883 courthouse and reflecting ponds. It is not known how long the reflecting ponds lasted. They were later turned into iris beds, which are still there. Stephens County residents have never had to apologize for their courthouse. (Basil Clemons Photograph Collection, Special Collections, UT-Arlington Libraries.)

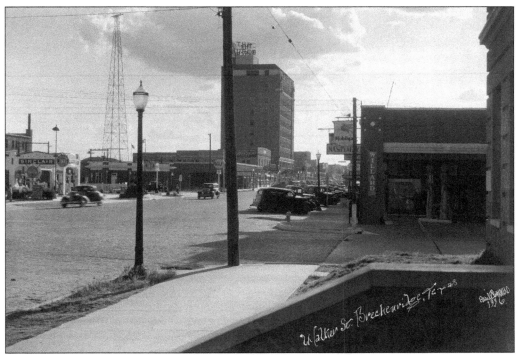

This 1936 view looks southwest down East Walker Street from the front of the YMCA. To the right, with the Willard and Mobilgas signs, is what later became Giles Tire. On the south side of the street are Sinclair and Gulf filling stations, and in the background, the Burch Hotel anchors the entire scene. (Basil Clemons Photograph Collection, Special Collections, UT-Arlington Libraries.)

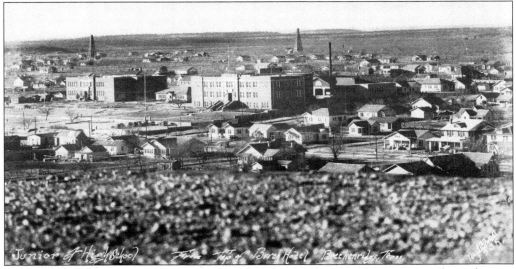

This 1935 picture shows the junior high and high school. An addition was made to the east of the former Central Grammar/Ward School when it was converted to the junior high. Note that the northern city limits, based on this picture, appear to be at about Third Street instead of extending to Seventh Street. (Basil Clemons Photograph Collection, Special Collections, UT-Arlington Libraries.)

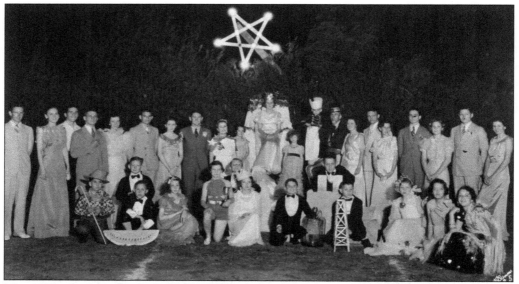

The 1935 coronation with Queen Ruth Clark was held at the football field. Coronations were no one-evening, escorted-by-dad-or-some-smelly-football-player event but involved tuxedoes and evening gowns, week-long drills in walking slowly in step and assisting ladies up steps, and courtiers standing regally during the festivities. Only the queen was seated during the hour-long entertainment of comedy, song, and dance. (SMM-BCC.)

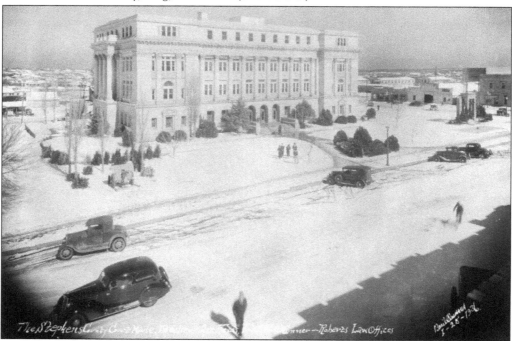

This 1936 view shows the courthouse and environs blanketed with snow. To save on costs, only the west courtroom was initially outfitted. However, the heat from the western sun and concerns with acoustics led the district court to move to the east courtroom in November 1927, where it remains to this day. (Basil Clemons Photograph Collection, Special Collections, UT-Arlington Libraries.)

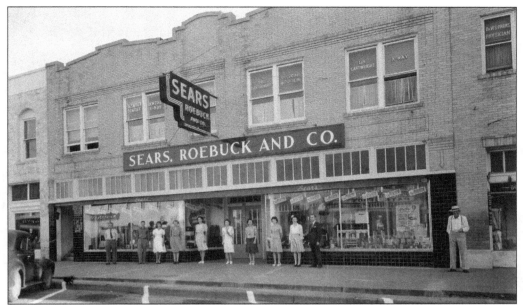

Sears, Roebuck & Co.'s location on the north side of Walker Street is pictured with its employees. This is the present location of Thurmon's Furniture. A full-blown department store was at this location, including automotive and tire service at a garage area behind it facing Court Avenue. Sears moved into a smaller location across the street around 1964 and became primarily a catalog store. (Basil Clemons Photograph Collection, Special Collections, UT-Arlington Libraries.)

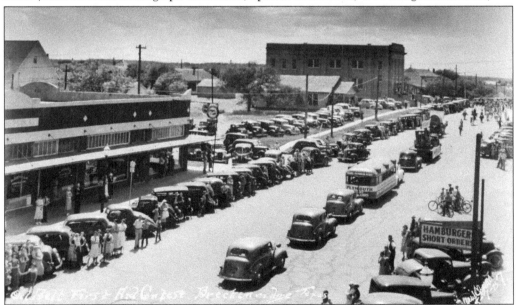

This 1937 First Aid Contest parade picture was taken looking southwest down Walker Street and shows the end of the south side of the 300 block of West Walker Street continuing to the old Methodist church. It is a great picture of the bus and crowd and what could be a sign for Nail's Café on the right. (Basil Clemons Photograph Collection, Special Collections, UT-Arlington Libraries.)

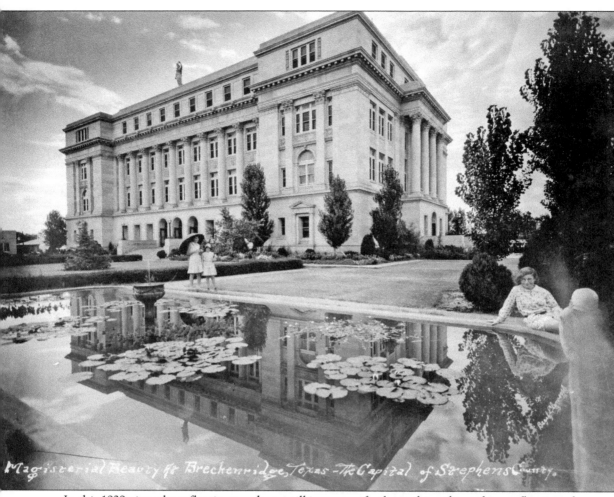

Magisterial Beauty ft Breckenridge, Texas - The Capital of Stephens County.

In this 1939 view, the reflecting ponds are still in use, perfectly catching the striking reflection of the majestic courthouse. Citizens are enjoying this civic treasure and its reflecting ponds. Lady Justice was moved from the 1883 courthouse to the new courthouse after the demolition of the old structure, and she reappears atop the new courthouse after an extended absence. There are varying accounts of Lady Justice's present whereabouts. Some claim she miraculously fled on her own from embarrassment after a particularly startling outcome in a murder trial. (Basil Clemons Photograph Collection, Special Collections, UT-Arlington Libraries.)

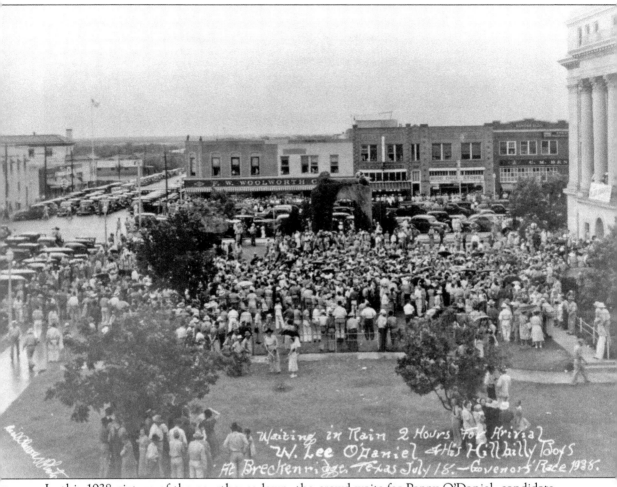

In this 1938 picture of the courthouse lawn, the crowd waits for Pappy O'Daniel, candidate for governor, to appear along with his Hillbilly Boys band. It also provides a great view of the Woolworth's store across the street to the left, Bender's Department Store to the right, and the 1934 post office in the background on Williams Street. (Basil Clemons Photograph Collection, Special Collections, UT-Arlington Libraries.)

This May 5, 1939, picture shows R.E. Dye Machine & Supply. R.E. Dye Supply and R.E. Dye Manufacturing would later be separated. The manufacturing side machined parts for Bell Helicopter, Lockheed, General Dynamics, and others while providing quality employment for graduates of Breckenridge High School's shop program. The manufacturing aspect continues to operate over 75 years after this picture. (Basil Clemons Photograph Collection, Special Collections, UT-Arlington Libraries.)

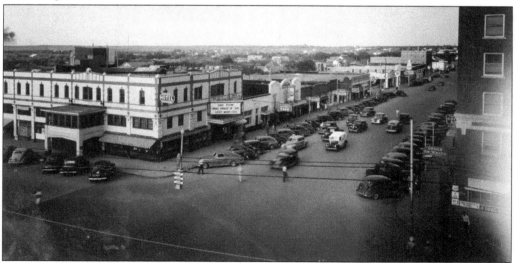

The Sager Hotel, on the left in this 1946 picture, was completed on the northeast corner of Walker Street and Breckenridge Avenue in 1920. Built at a cost of $180,000, it was plush. Many oil deals were cut at this, Breckenridge's most elegant hotel, during the height of the boom. It was razed in 1969. (Basil Clemons Photograph Collection, Special Collections, UT-Arlington Libraries.)

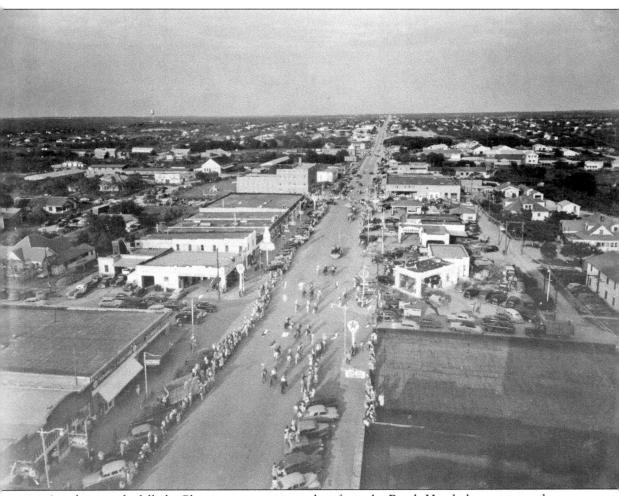

Another wonderfully lit Clemons masterpiece, taken from the Burch Hotel, demonstrates the changes since the earlier picture of the same general area on page 66. Once again, a parade is going on in this undated photograph. Now there is the familiar row of filling stations on the south side of the 200 block of East Walker Street, and east of them is the Ford house. Across the street, Alexander's Ice Cream, a popular teen hangout of the time, is just east of Witcher Service Station, located in the building on the corner where the Cook Building presently stands. The YMCA rises in the distance, and behind and east of it are Bloxom Feed Store and Breckenridge Tool, which made and fixed cable tool bits in its furnaces into the late 1960s for use in Mexico. Farther in the distance is the eastern part of Breckenridge. (Basil Clemons Photograph Collection, Special Collections, UT-Arlington Libraries.)

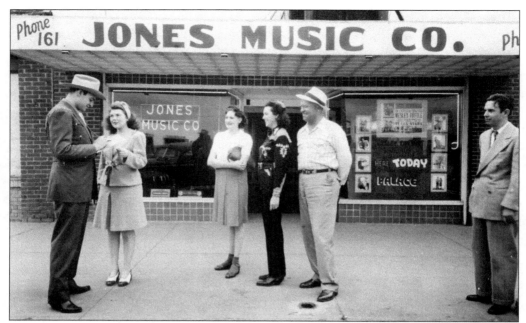

Jones Music was located at 214 East Walker Street at the time of this 1946 shot. This building is presently Happy Days Antiques. Wesley Tuttle was a major recording and movie star at the time. He did the yodel for Dopey in Disney's original *Snow White*. He appeared at Jones Music store during the day and did a live performance that evening at the Palace Theater. (SMM-BCC.)

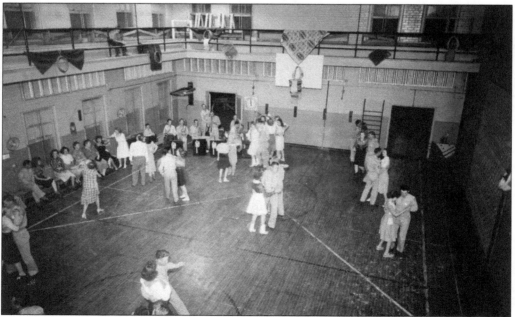

Local ladies entertain soldiers in this 1944 USO dance picture. This is a great interior shot of the much-used YMCA gym. It is clear where the term "key" for the lane in basketball came from by the markings seen here. Half court in this gym was about a current NBA three-point shot, and the brick walls appeared very suddenly on fast breaks. (SMM-BCC.)

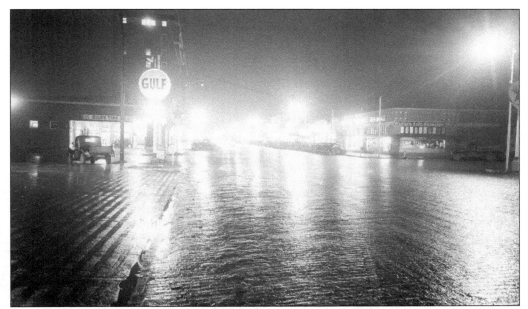

This night view looking west up Walker Street during a rain shows Giles Tire, in its Baylor Avenue–Walker Street location, and Western Auto, visible in the downtown lights. A little rain seemed to immediately transform Breckenridge into a beautiful place. Even mesquite trees in summer can be enticing when drenched. (Basil Clemons Photograph Collection, Special Collections, UT-Arlington Libraries.)

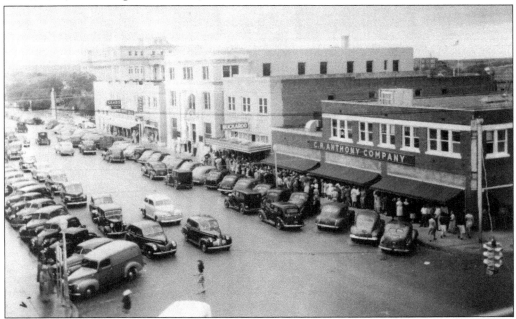

The grand opening of C.R. Anthony in Breckenridge took place on June 20, 1946, on the northwest corner of Walker Street and Breckenridge Avenue. This is a nice view looking northwest down Walker Street. Like J.C. Penney's, Anthony's had a cash carrier cable system to zip-line cash to an upstairs office for change, which was a great joy to see operated. (SMM.)

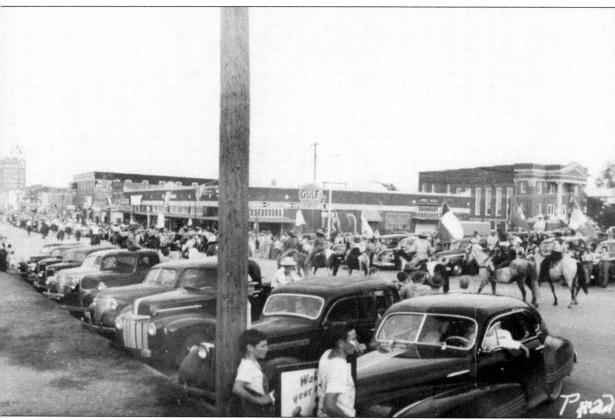

This nice shot of downtown as it looked during the 1947 rodeo parade looks southeast from mid-block between Miller and McAmis Streets, with a good view of the Gulf station (with the Williams

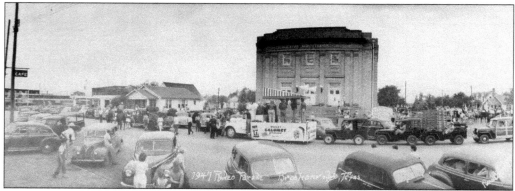

Sheb Wooley and the Calumet (Baking Powder) Indians perform on a float in front of First Methodist Church as part of the 1947 rodeo parade. Sheb Wooley had a novelty hit in 1958 with "The Purple People Eater." He also recorded parody songs as Ben Colder and was an actor appearing in *High Noon* and on *Rawhide*. (SMM-BCC.)

Rodeo Breckenridge 266

Street Church of Christ roof showing), the Presbyterian church, and the rest of downtown trailing into the distance. (SMM-BCC.)

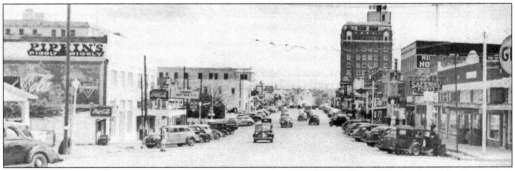

This 1949 view of downtown includes some signs that can be made out in the 300 block of West Walker Street. Pipkin's Piggly Wiggly is in the building that was later Thurmon's Furniture, Davis Manufacturing, and then Baxley Furniture and, of course, Nail's Café, now expanded to the rear. On the south side is the sign for the Safeway Store on the east end of what was later Ewing-Christian Hardware. (BISD.)

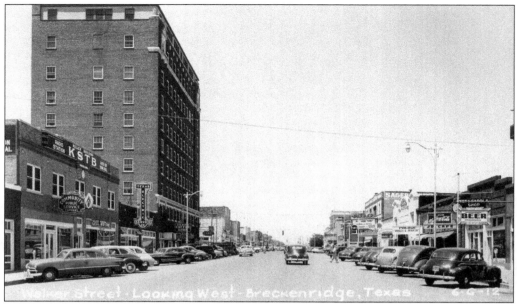

This 1949 view of downtown looks west from Baylor Street. At right are the Busy Bee and the Ideal Café, two of Breckenridge's downtown beer joints. In the 1960s, there were five beer joints on the north side of the 100–200 block of East Walker Street, patronized by those who didn't much care what anyone thought. (Author.)

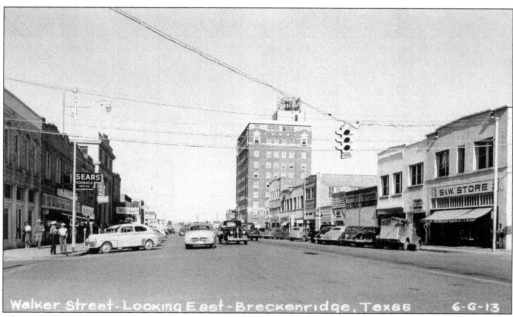

This is a 1949 picture of downtown looking east from Court Street. The S&W 5&10, on the far right, is where Winn's dime store would operate into the early 1960s. The upstairs in this building housed the telephone operators until Breckenridge switched to automatic dial on December 16, 1956. (Author.)

This 1949 picture of McConnell Motor & Imp. Co. at 220 West Elm Street, across from the courthouse, shows, from left to right, Harwell, Porter, and Eldon "Mac" McConnell. This building is still there. T&P Oil had offices there recently. Porter McConnell later owned a feed store on South Breckenridge Avenue just south of West Cottage Street. (Anna McConnell Easter.)

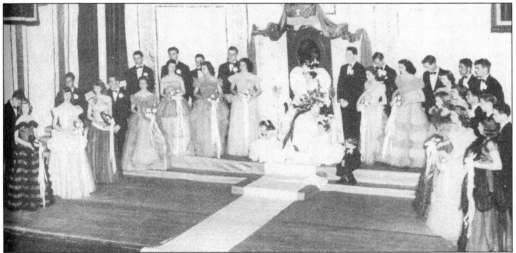

Full skirts are in for the 1949 coronation celebration for Buckaroo Queen Millie Myers, Great Lord Chamberlain Marvin Newberry, and the royal court in the Breckenridge High School auditorium, including trainbearers Sharon Wilkerson (left) and Trudy Thomas (right) and crown bearer Sammy Fambro. Ushers and announcers were also in evening wear for this formal night. Nearly every responsible student played some role in these grand productions. (BISD.)

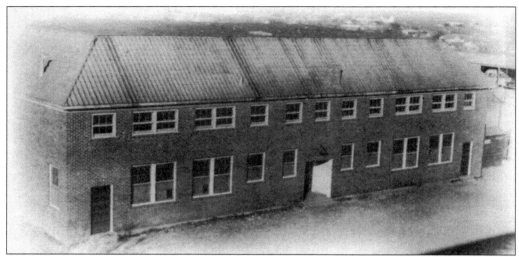

This gym was completed in 1927. The floor was not quite full size, but at least it had a high ceiling, unlike the prior basement gym. There were no signs, landscaping, lawn, or sidewalks. A single floodlight lit the front entrance. The gym had no public restrooms, and the backboards were sheetrock. This was the main gym until L.T. Cook was completed for the 1969–1970 season. The building was repurposed and is still in use. (BISD.)

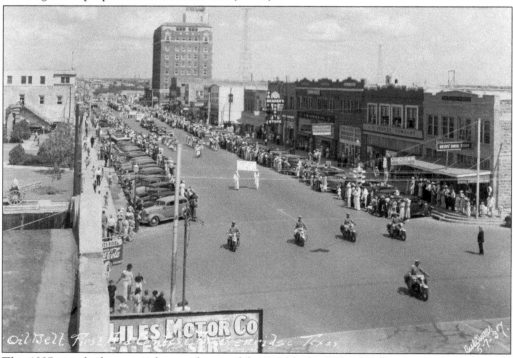

This 1937 view looks east with a good view of the 200 block of West Walker Street. In the middle of the block is Bender's Department Store, occupying the eastern two-thirds of an imposing two-story building that abuts J.C. Penney's on the west. Peeler's later occupied the west third of this structure. The entire building burned down in 1953. Peeler's rebuilt, but Bender's did not. (Basil Clemons Photograph Collection, Special Collections, UT-Arlington Libraries.)

Six

THE 1950S
FOOTBALL DYNASTY

During the 1950s, when a new Class AAA was formed, Breckenridge, which until 1951 had played in the largest Texas football classification, won four state championships and tied for another, going 99-20-4 for the decade, with half of those losses to AAAA powers more than 10 times its size.

Regardless of injuries or illness or off days or opponents always giving their best shot, the Bucks expected to win even when playing much larger schools. And win they did, although undersized and outmanned. A favorite story was of a 1958 scrimmage with Fort Worth Paschal, which bussed over 100 players to town and lined them up opposite the 21 or so Bucks, who proceeded to decimate the city kids. The Paschal coach was running up and down the sidelines hollering, "Is there anyone here who wants to play like one of these Buckaroos?"

The 1950 census tallied the population of Breckenridge at 6,610, which by 1960 had shrunk to 6,273. Of the 20 defeats suffered in that decade, 10 (and one tie) were at the hands of two AAAA powerhouses from much larger cities with only one high school: Abilene (population 45,570 in 1950 and 90,368 in 1960) and Wichita Falls (population 68,042 in 1950 and 101,724 in 1960). Combined, Abilene (1954, 1955, 1956, 1957) and Wichita Falls (1950 and 1958) won six AAAA state championships in the 1950s. The Bucks defeated three of those eventual AAAA state champions, Wichita Falls 18-0 in 1950, Abilene 35-13 in 1954, and Wichita Falls 26-22 in 1958.

Of the remaining 10 defeats incurred in the decade, seven were during two rebuilding years, 1956 (a 4-6 record) and 1957 (7-3-1). Interestingly, the Bucks defeated much larger Wichita Falls both of those years.

Cleburne, which tied Breckenridge in the 1959 championship game on a two-point conversion, had a 1960 population of 15,381. Kingsville, which Breckenridge soundly defeated (42-14) for the state title in 1958, had a 1960 census count of 25,297.

Dr. Frank C. Payne was team physician from 1947 into the 1970s. He played at Southern Methodist University, sometimes sneaking back home to Rockwall to play high school ball for his alma mater, and had four sons who were Bucks. Frank Jr. backed Doak Walker at Southern Methodist, and Ronnie and Jerry played at the University of Oklahoma. Here, Dr. Payne is examining Bennett Watts's finger in 1955. (BISD.)

The 1951 squad pictured here defeated Temple 20-14 in Abilene for the state title under coach Cooper Robbins (back row, left). Three Junction Boy survivors at Texas A&M, Bobby Drake Keith (21), Bobby Lockett (77), and Donald Robbins (81), were on this team. Quarterback Kenneth Ford (20), end Donald Robbins, and tackle Gary Rice (77) were All-State in 1951. (SMM.)

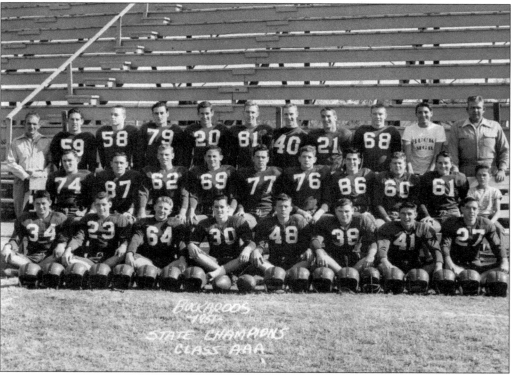

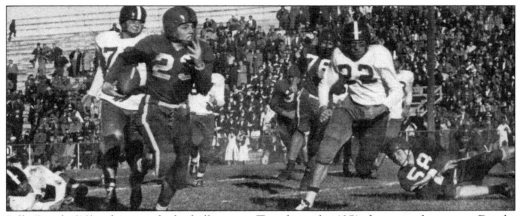

Billy Dendy (23) is loose with the ball against Temple in the 1951 championship game. Dendy, a sophomore in this picture, was named Honorable Mention All-American and All-State his senior year and went on to have a successful high school coaching career. All-Stater Gary Rice (76) pursues, and Jerry Tubbs (58) is on the ground. (BISD.)

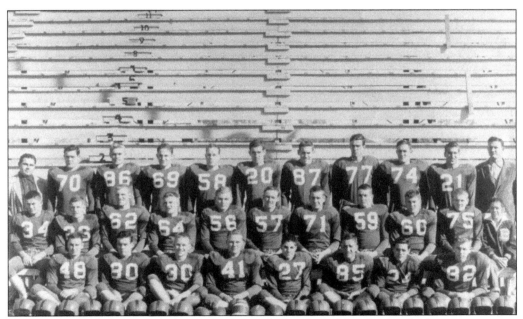

Under new coach Joe Kerbel, the Bucks defeated Temple 28-20 at Baylor Stadium to repeat as AAA state champs. All-State players on this squad were Jerry Tubbs (58), Kenneth Ford (20), Wayne Greenlee (69), and Bobby Lockett (77). Billy Dendy (23), Houston Green (62), and Tommy Beasley (87) made Second-Team All-State. (SMM.)

Jerry Tubbs is the most successful player from Breckenridge high school. He lost only three games in high school and none in his varsity career at the University of Oklahoma, where he played center and linebacker except for the year he was moved to fullback after another player's injury. Although Tubbs had never played in the backfield previously, he responded by averaging 6.1 yards per carry and then going back to his center position the following year. He finished fourth in the Heisman balloting his senior year, very high for a lineman. After a brief career elsewhere, he was taken in the 1960 expansion draft for the brand-new Dallas Cowboys. He started at middle linebacker and served as a player-coach and then as linebacker coach in a career spanning the entirety of Tom Landry's tenure with the Dallas Cowboys. He is in the Texas High School Football Hall of Fame (1971) and the College Football Hall of Fame. He was an honors graduate of Breckenridge High School and an academic and unanimous collegiate All-American in 1956. (BISD.)

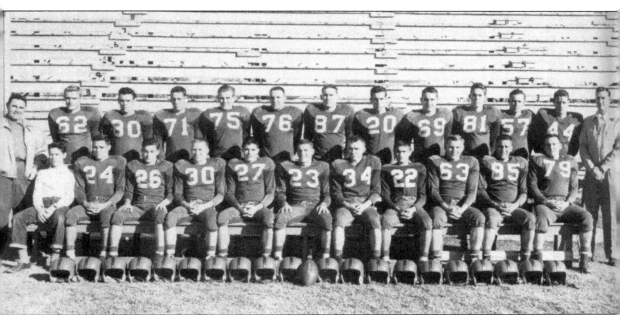

Led by two-time All-State quarterback Ken Ford and other holdovers from the two-time champs such as Billy Dendy and Tommy Beasley, as well as a group that would be stars of the 1954 state championship team (Jakie Sandefer, Dick Carpenter, Jerry Payne, Jerry Cramer, Sonny Everett, and Larry Munnerlyn), the 1953 Bucks were a powerful passing team some considered its finest group ever. They lost 6-0 to a larger, run-based Big Spring team in district with three inches of water and slick mud on the field. Bill Creagh claimed referees had to rush in and untangle the piles quickly so the players on the bottom would not drown. Unlike in modern times, when entire districts may wind up in the playoffs, in 1953, only the district champ advanced. Similar to the 1929 team being stopped by the elements (14 inches of snow) and only able to tie, the torrential rains in 1953 very well may have cost the Bucks a championship. (BISD.)

Joe Kerbel took over the Bucks in 1952 and won the state championship in two of his three years at the helm. He was a dynamic showman, and Quarterback Club attendance got up to 500 during his tenure. He was a tough-as-nails coach who kept the respect of his players. The Quarterback Club covered his $200-plus-a-month phone bill for calls to Bud Wilkinson at the University of Oklahoma to discuss strategies. (BISD.)

Tommy Beasley (87) catches a pass during a 35-13 trouncing of the eventual 1954 AAAA champ Abilene Eagles, with John Cotten (82), who would later come back and coach in Breckenridge, trailing the play. Abilene would not lose a game again until 1958. Beasley holds the distinction of playing on three state championship teams, 1951, 1952, and 1954. (BISD.)

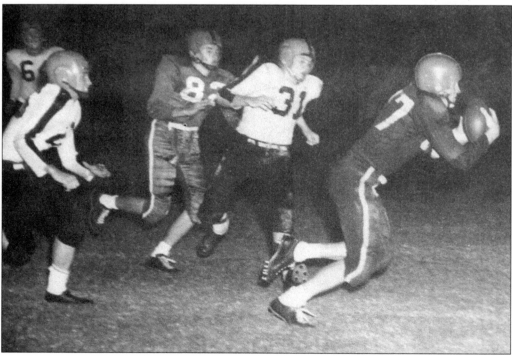

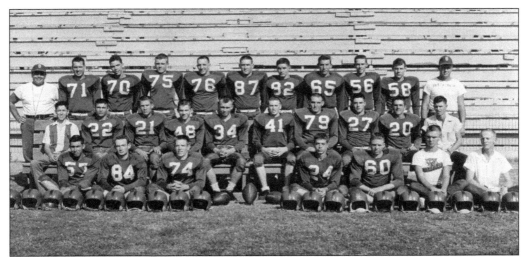

Coach Kerbel's Bucks won the state title again in 1954, defeating Port Neches in Buckaroo Stadium by a score of 20-7. Jerry Cramer (75) was an All-American and Jakie Sandefer (27) an Honorable Mention All-American. Cramer (71), Sandefer (27), Bennett Watts (20), and Sonny Everett (76) made First-Team All-State. This squad hammered both Wichita Falls (41-13) and Abilene. (SMM.)

Carrie Lynn Sandefer (seated) and Jake Sandefer (far right) host football royalty at their home. From left to right are I.B. Hale, two-time All American Tackle at Texas Christian University; Davey O'Brien, 1938 Heisman winner; Sammy Baugh, hall-of-fame quarterback; Jack "Sleepy" Harris, Breckenridge native and assistant Buck coach; and Joe Kerbel, head coach of the Bucks. (SMM.)

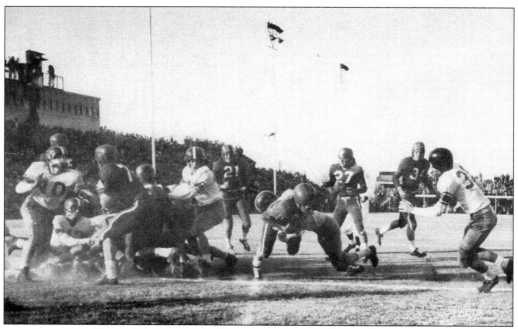

Quarterback Bennett Watts (20) scores against Port Neches. Watts, Jakie Sandefer (27), and Dick Carpenter (34), all shown in this picture, would all play for Bud Wilkinson at Oklahoma during its still-record win streak, as would linemen Larry Munnerlyn (60) and Jerry Payne (58). Sandefer was an elusive and exciting broken field runner with a 9.8-second 100-yard speed who excited both Breckenridge High School and Oklahoma fans with spectacular runs. (BISD.)

Emory Bellard took over as head coach of the Bucks in 1955 at the age of 27. He did not use or permit profanity and never belittled his players but commanded their respect. He won back-to-back titles in 1958 and 1959 despite having no players go on to play Division I football. He invented the wishbone offense and coached at Texas A&M and Mississippi State. (SMM.)

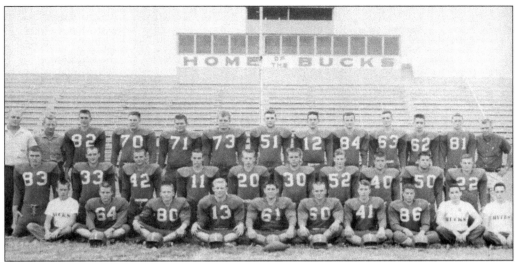

This group defeated eventual AAAA champion Wichita Falls and defeated Kingsville 42-14 for the 1958 AAA title. It was named the Team of the 20th Century by the *Fort Worth Star-Telegram*. Charles Huddleston (73) was a consensus All-American and All-State, and Joe Ed Pesch (42) was an Honorable Mention All-American and All-State. (BISD.)

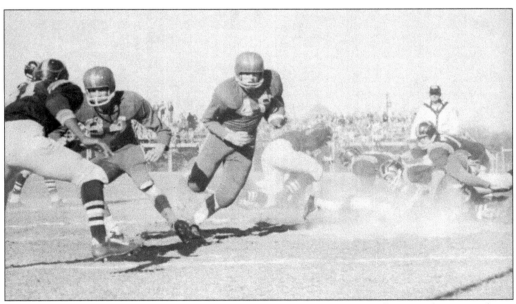

Dickie Rogers (40) scores a touchdown in the state final against Kingsville in Buckaroo Stadium. The Buckaroos were in constant motion. After a play, they hopped back up and were ready to go again. A Buckaroo never sat or kneeled down. A Kingsville fan said they "Come up to the scrimmage line, squat down, and then take off like a covey of quail." (BISD.)

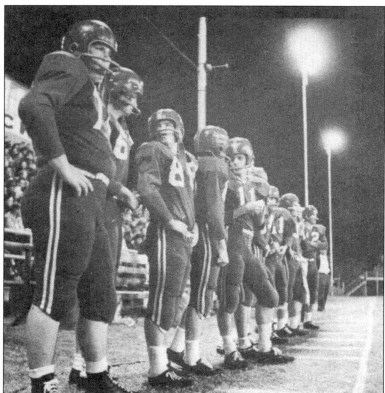

Reserves stand with their helmets on ready to enter the fray at any moment, a Buckaroo tradition—along with waterless practices and games—since Eck Curtis's arrival in 1935. The 1958 Bucks outscored their opponents 128-35 in the playoffs. The Bucks kicked one extra point in the first game of the 1958 season but went for two after every touchdown from the second game on. (BISD.)

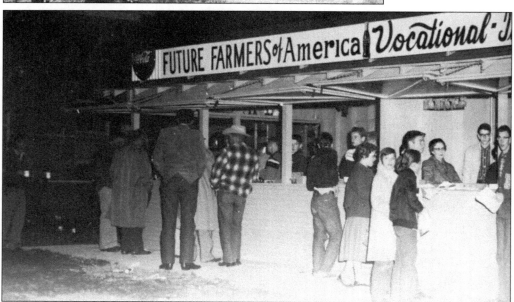

The east end of the concession stand, shown in 1958, is where various clubs tried to keep the fans warm and fed on fall nights. It combined with the gym and restrooms to close off the south end of the field, which was enclosed on the other three sides by bleachers, for a sort of bowl feel. (BISD.)

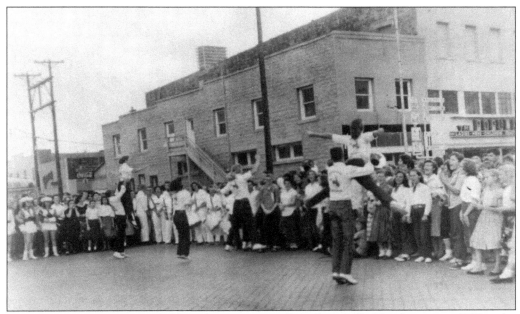

Every home game was preceded by a downtown parade and pep rally like this one in 1958 at the intersection of Highway 180 and Highway 183. Traffic on those highways was far less important than cheering on the beloved Buckaroos. The Popular store can be seen on the right, and good eyes may see part of the little café behind Bowen's Drug known as Pop's Place or Jack's. (SMM.)

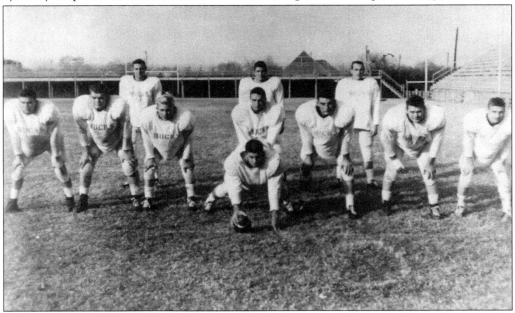

The offensive starters for the Team of the Century are pictured in their high-dollar practice uniforms. They are (on the line) left end Larry Parker, left tackle Glenn Dixon, left guard Larry Kimberlin, center Ronnie Martin, right guard Joe Crousen, right tackle Charles Huddleston, and right end W.H. Roberts; (in the backfield) quarterback Jerry Gibson, left halfback Jimmo Wilson, fullback Dickie Rogers, and right halfback Joe Ed Pesch. (SMM.)

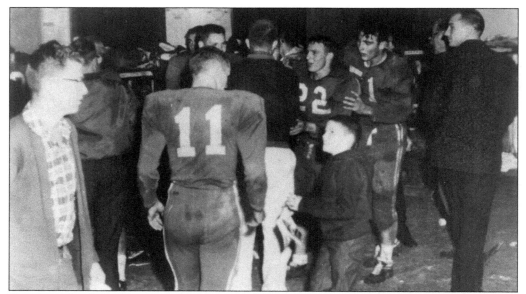

Fans are in the dressing room congratulating their heroes after defeating the Weatherford Kangaroos to win the district in 1958. The Buckaroos were well known in town, and the community felt an ownership of the players they admired and of whom much was expected. (SMM.)

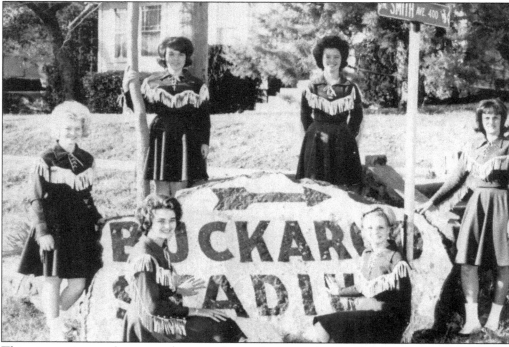

This picture is out of sequence but was chosen for its good view of the iconic and semi-sacred Buckaroo Rock, surrounded by the pretty 1964–1965 cheerleaders. This rock is found as early as the 1940 yearbook. It was frequently vandalized before key games, although it was never clear if the guilty party was the opponent or just coaches or townspeople trying to motivate the team. Note the Buckaroo on the green street sign. (BISD.)

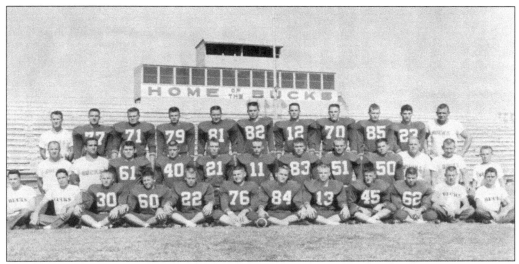

Cleburne converted for two points in the waning seconds to tie the Bucks 20-20 before 10,000 fans at Buckaroo Stadium, making Breckenridge co-champions again, 30 years after their first shared title. Glenn Dixon (71) was named Super All-State and Jerry Gibson (11) and Dickie Rogers (40) were All-State as the Bucks won back-to-back titles for the second time. (SMM.)

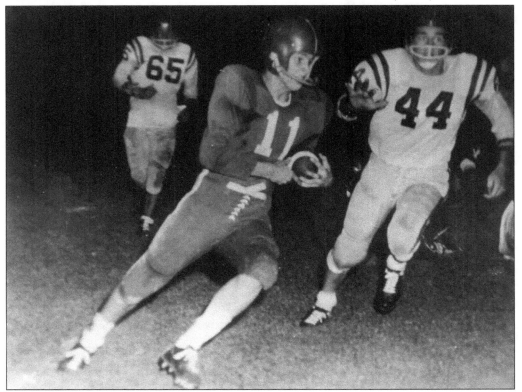

Quarterback Jerry Gibson (11) carries the ball in this shot. Emory Bellard began development of his revolutionary wishbone offense while in Breckenridge, as attested by the significant rushing yards from multiple backs and plenty of fumbles early in the season. (BISD.)

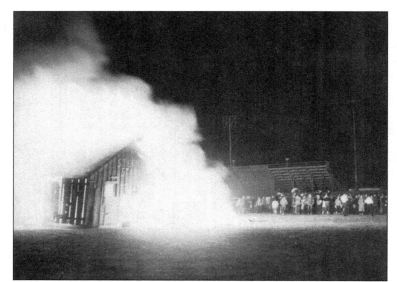

The annual bonfire takes place in 1955 on the dirt parking lot west of the stadium. Most schools have bonfires, but few have them for teams that are giant killers who have won the state championship three of the past four years and will win two more before the decade is done. (BISD.)

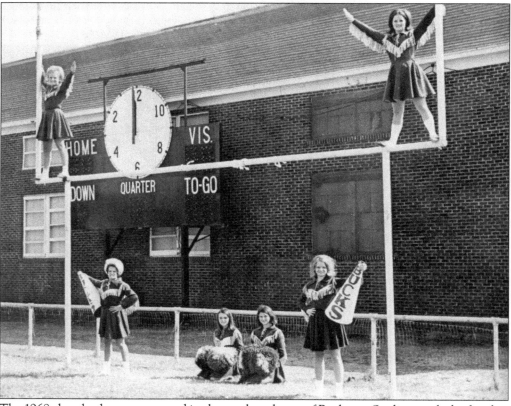

The 1968 cheerleaders are arranged in the south end zone of Buckaroo Stadium with the familiar scoreboard and clock in the background. The cheerleaders, from left to right, are (perched on the goalposts) Kay Mitchell and Mary Elliot; (standing) Pam Pearson and Billie Pierce; (kneeling) Betty Jo Knight and Meggan Wright. Some believe God compensated for lesser football teams after the 1950s by making the girls a little bit prettier. (BISD.)

102

Seven

Living in the 1950s

Breckenridge enjoyed a measure of post–World War II prosperity offset somewhat by slow times in the oil and gas sector for much of the decade. There were merchants in town ready to sell anything one needed. The downtown was fully occupied. The two-story Bender's Department Store, located across Walker Street from the courthouse, burned down, along with the adjoining Peeler's, on August 2, 1953. Peeler's rebuilt, sharing a party wall with J.C. Penney's, but Bender's was never rebuilt or reopened, leaving a vacant space in the store fronts until replaced by a new Ben Franklin in 1961.

The "Drag" in the 1950s extended from the Dairy Delight No. 1 on East Walker Street to the Dairy Delight No. 2 on West Walker Street. The Dairy Delight No. 1 had more room, a kid-friendly owner, and a slick exit where even a not-very-impressive family car could spin out to impress the girls. In the later 1950s, the Dairy Mart was built farther west on Walker Street with more space to hang out, and it became the new western end of the Drag. There was also briefly a Dairy Land located near Oakwood and Walker Streets in the late 1950s competing for the business of teens.

A young Elvis Presley appeared at the Breckenridge High School auditorium on April 13, 1955, and returned on June 10, 1955, to do two shows at the American Legion Hall, giving eternal bragging rights to the girls he took on a date during each visit.

A school building program took place in the late 1950s, mostly by necessity after a fire and two buildings were condemned. A series of plain, one-story, un-air-conditioned structures, all of which are still in use, were built following bitterly contested bond elections to fund their construction.

The new Safeway Store in the 300 block of North Breckenridge Avenue was built in 1956, as was the Southwestern Bell Telephone building in the 200 block.

In 1956, Lester Clark was elected a trustee of Texas Christian University, joining Breckenridge's Milton Daniel, who was chairman of the seven-man board.

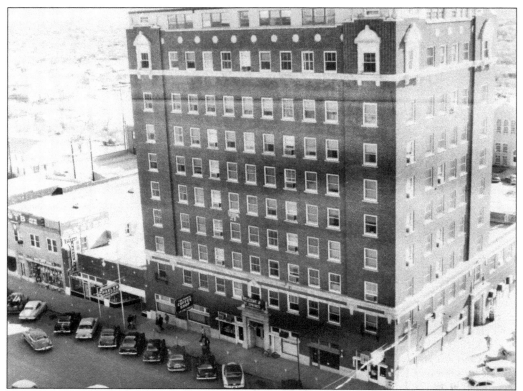

The Burch Hotel is pictured in December 1953 while it was hosting Big Spring in its playoff game with Gainesville to be held at Buckaroo Stadium. Peeler's was temporarily located in the low portion east of the hotel while it rebuilt its store, destroyed by fire along with Bender's Department Store. (SMM.)

Kiker's Funeral Home is seen in the snow. Don and Mary Melton bought this funeral home from Kiker's in 1954 and changed its name to Melton's Funeral Home in 1955. Melton's built its present location on the southeast corner of Miller and Williams Streets in the early 1960s, and it is now known as Melton-Kitchens Funeral Home. The pictured house was demolished to make a parking lot for the Methodist church. (Basil Clemons Photograph Collection, Special Collections, UT-Arlington Libraries.)

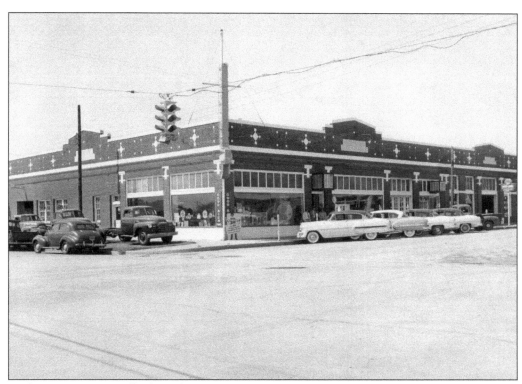

In the 1950s, McDowell Chevrolet was located on the southwest corner of Court and Williams Streets. This was originally a Ford dealership, and it later became Bagwell Chevrolet, then Camp Chevrolet, and then McDowell Chevrolet. Gus Gallagher, an All-State guard for the Buckaroos in the 1940s, was with McDowell's in the 1960s. (SMM.)

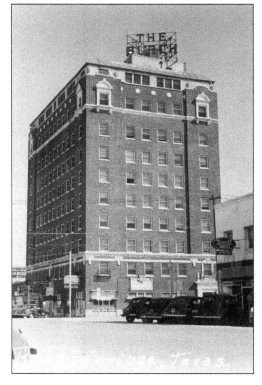

For the observant, Burch Hotel is at this time spelled out on the top edge of the roof. Six-foot-four Eugene "Shorty" Thompson was manager and co-owner, with brother Claude Thompson, of the Burch for 40 years or so. It retained the Burch Hotel name as long as it was operated as a hotel. It was sold in January 1970 to become the new home for the First National Bank. (Author.)

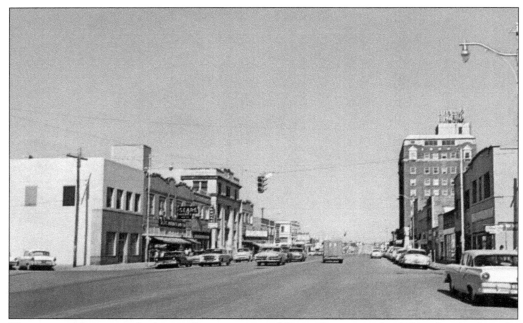

This view of downtown looks east from just west of Court Avenue in the 1950s. On the far right is Winn's dime store, where Sears moved when it downsized. This picture provides a good view of both sides of the 100 block of West Walker Street. The red neon sign on the Burch now reads "Hotel Burch" instead of "The Burch." (Author.)

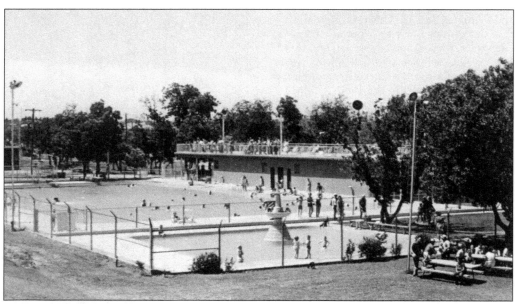

Arthur Miller Park and its grand pool and youth center were dedicated on July 4, 1953, with a Miss Breckenridge contest. It provided swimming in its Olympic-sized pool, as shown here, and a lot of pecan tree shade and a huge hill coming down from the American Legion Hall, which was popular when it snowed. (Author.)

Kids are hanging out at the Dairy Delight No. 1 on East Walker Street in 1955. From left to right are Jeannie McClung, Eddie Offield, Caroline Sikes, Kay Ewing, Ronnie Payne, Treva Greenlee, Tony Andress, Samantha Boyd, and G.B. Greiner. This was later reopened by the same owner in the 1960s as the Anchor. (BISD.)

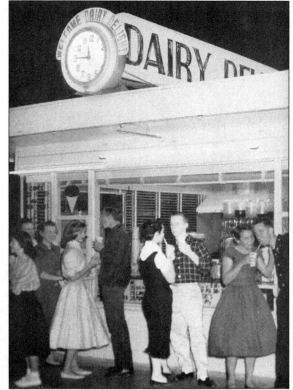

This modern station on the southeast corner of Breckenridge Avenue and Elm Street opened March 18, 1956. Built by Marvin Naylor, it was first run by Doyle Newcomb. In the 1960s, it was Duvall's Texaco. The building has been razed, which is unusual in Breckenridge for a building that never burned. (SMM.)

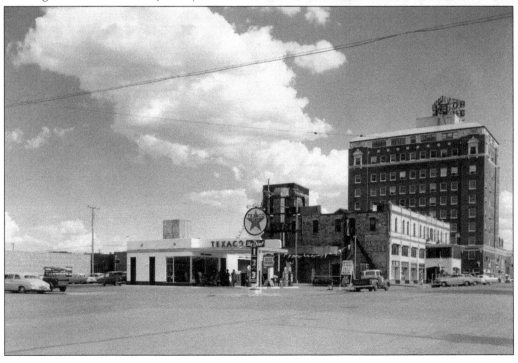

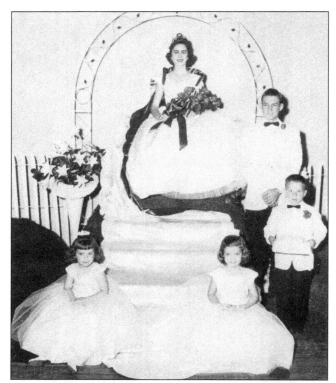

Buckaroo Queen Janis Knox and Great Lord Chamberlain Kenneth Satterwhite, with crown bearer Emory Bellard Jr. and train bearers Elaine Cox (left) and Ann Black (right), are the centerpiece of the 1957 coronation. There were higher academic and citizenship requirements for the queen and her escort, who also served as the student body president. (BISD.)

After expanding to the back in the 1940s to become a 12-stool outfit, Nail's Café was expanded a second time east about three feet to join the wall of the existing Davis Building. A row of small tables was added along the east wall to reach the present configuration of the building, which still serves fine burgers as Pam's Café. (Jimmy Nail.)

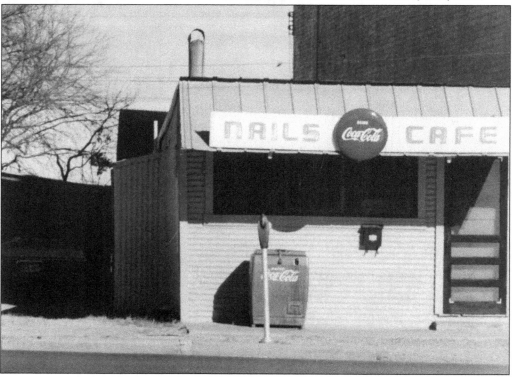

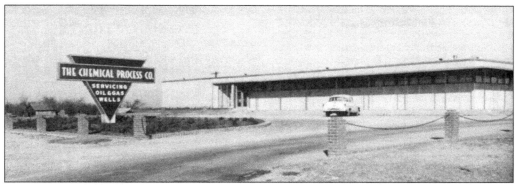

This building was constructed for the Chemical Process Co., a pioneer in the process of acidizing wells (first done in 1925) and fracking. It was founded in Breckenridge and sold to Borg Warner Corporation in 1956. The building is still in use and is now best remembered for C.D. Doffelmeyer's stuffed polar bear, which stood in its entry for years. (SMM.)

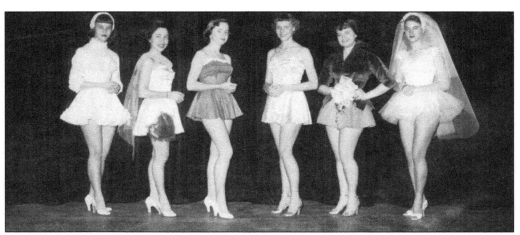

Calendar girls were presented at the 1955 coronation. Pictured are January through June, from left to right: Johnnye Lou Wilson, Estaline Tuck, Patty Clark, Alvis Morton, Patsy Pearson, and Pat Pitzer. (BISD.)

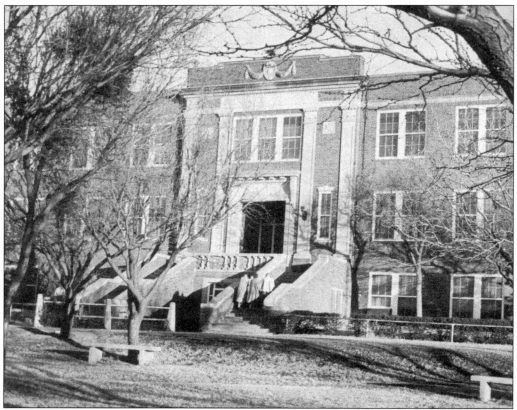

The beautiful high school is pictured here in 1958. A lot of dreams and excitement were shared by kids leaning against the pipe fences lining the sidewalks of this campus. Even after the new high school was built, this stately building with its high steps was a favorite background for yearbook pictures until it was demolished to make room for the new Bailey Auditorium. (BISD.)

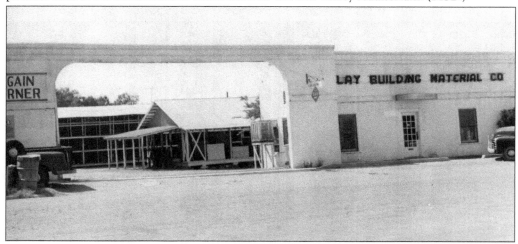

The Clay Building Material Co. was at 203 North Rose Avenue. This location had been a lumber yard going back to the boom days and operated into the late 1960s, when it was destroyed by a fire and never rebuilt. (BA.)

Eight

THE 1960S AND BEYOND

The Breckenridge Boys Choir, under the direction of Gwen Dean, appeared at John F. Kennedy's White House in 1962 and the New York World's Fair in 1964. Founded in 1952, the choir continued through 1981, influencing the lives of over 1,000 alumni.

Jack Cox, a Breckenridge oil man, ran for governor in 1962 as a Republican, bringing movie stars to town for a parade and landing a helicopter on the football field as part of his campaign. At a time when Texas was more Democratic than it is presently Republican, Cox managed to get 45.6 percent of the vote against John Connally.

In 1964, Breckenridge hosted the Texas State Little League championships at its field, which was always meticulously cared for by Nolan and Sally Luckett. The teams and their supporters stayed at the Burch Hotel, the YMCA, the Ridge, Maridee, Holiday Hills, and wherever else they could.

In 1965, Monte Stratton, under the tutelage of John Dale Lewis and John Cotten, tied the then-national high school record in the 100-yard dash with an electronically timed 9.4 seconds at the state meet, where he also won the 220-yard dash, and was a dropped baton in the 440-yard relay away from bringing a state championship to Breckenridge.

The Hubbard Creek Lake dam was completed in December 1962 and filled for the first time in the spring of 1965.

The 1960s were a time of economic development. Davis Manufacturing, which made blue jeans for Kmart, Kress, Target, and other major retailers, eventually hired hundreds at its factory at the new industrial park northeast of the water plant.

The second occupant of the new industrial park, Fin-Tex, was short lived, but the third, Vintage Homes, built mobile homes on a large scale and spun off numerous supporting industries, such as Strickler Industries, Ridgecraft, and Baxley Industries.

A new air-conditioned high school was completed in 1967, and a new junior high and gymnasium were completed and put into use for the 1969 school year.

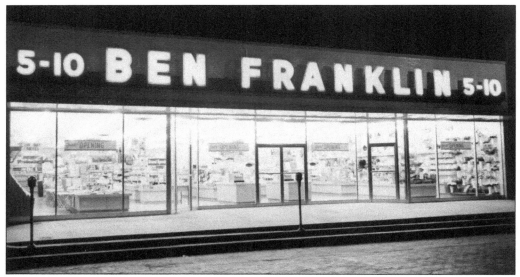

Pictured is the new Ben Franklin store at its grand opening on October 19, 1961. Built on the old Bender's site by Albert Reck, this is the only downtown store, other than the replacement Peeler's next door, that was built after the 1920s. It closed in December 1986 and then suffered the same fate as Bender's, burning down along with the adjacent Peeler's. (BA.)

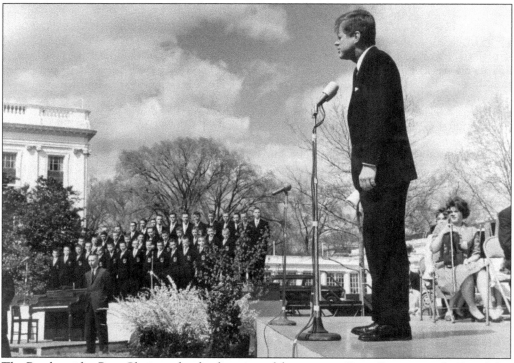

The Breckenridge Boys Choir, under the direction of the amazing Gwen Dean, waits for Pres. John F. Kennedy to finish speaking so they can show their stuff. Dean managed to simultaneously play the piano or organ and direct the choir and took them on cool trips while exposing them to culture and instilling a lifelong love of good music in her boys. (Frank Homme photograph, SMM.)

Curt Homme shakes the hand of the most glamorous first lady in history following the Boys Choir concert at the White House. Beside Homme are Bobby Buchanan, left, and Larry Fry. Older choir members blamed their mothers' training, to never shake a lady's hand unless she extended it first, for missing this once-in-a-lifetime opportunity. This picture appeared in newspapers around the world. (AP Photo/Bob Schutz.)

The mile-long bridge over Hubbard Creek Lake is complete and spans dry land, waiting for the rains to fill the lake after the dam was completed in December 1962. Finally, in the spring of 1965, the rains came down, the floods came up, and the lake was filled at last. (SMM.)

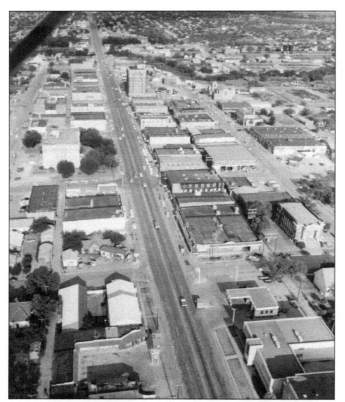

This aerial view shows the bustling downtown looking east in the early 1960s. Visible are the Holiday Hills Motel & Coffee Shop, the Presbyterian church, the Firestone Building, and other familiar landmarks. The presence of both Ben Franklin and the beautiful Presbyterian church date this picture to 1961–1963. (SMM.)

Breckenridge's immaculate Little League ball park, with real sunken dugouts and no weeds, hosted the 1964 Texas State Little League tournament thanks to the efforts of Bill Black. A first-class Little League program that provided uniforms like the big leaguers wore was one of many cool things for kids in Breckenridge. (Frank Homme photograph, SMM.)

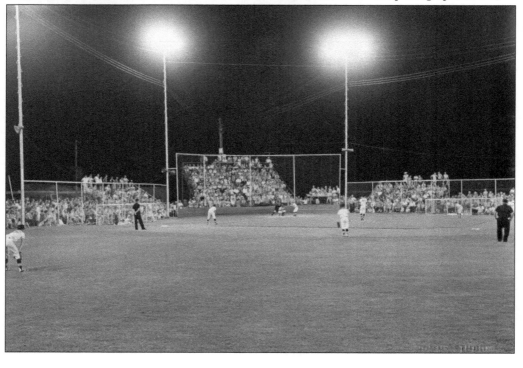

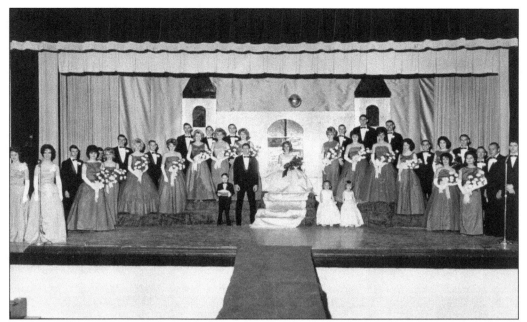

Buckaroo Queen Ramona Choate and Great Lord Chamberlain Randy Howell are pictured with their court. Homecoming queens reign only one night, but Buckaroo queens reign a school year. Most of the court was popularly elected, so snotty people were eliminated. Perhaps striving for those posts brought out the best in people. (Frank Homme photograph, SMM.)

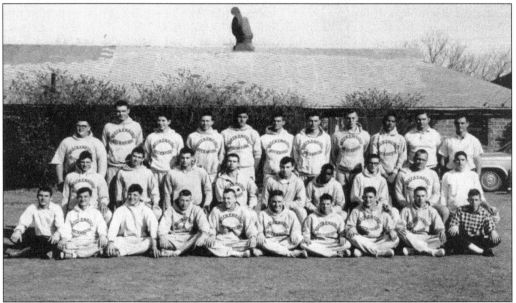

Monte Stratton (first row, fifth from left) and the 1965 track team are pictured in front of the Buckaroo fieldhouse. Knowledgeable track coaches John Lewis (third row, far right) and John Cotten (third row, second from right) turned several of these guys besides Stratton into collegiate track stars: John Hagler (third row, fifth from right), Dennis Stephens (second row, far right), Frank Riney (second row, second from left), and Warren Hart (third row, fourth from right). (BISD.)

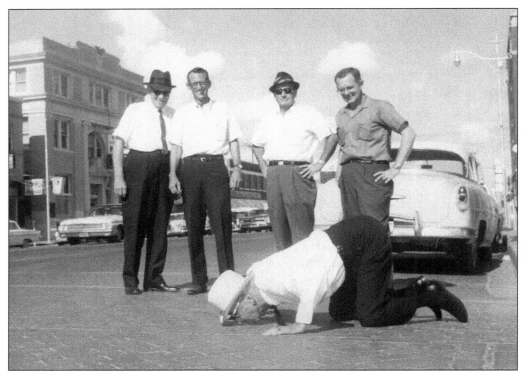

Claude Peeler, a fiery business and civic leader, launched a successful campaign in the early 1960s to save the downtown's distinctive 1923 brick streets from being paved over by the state. In this picture, Claude kisses the bricks he so valiantly saved while, from left to right, Mayor Charlie Sommer, City Manager James Swaim, and Commissioners Albert Reck and Frank Homme look on. (Frank Homme family.)

The Dairy Delight No. 1 drive through, the eastern end of the Drag, was remodeled into the sparkling new Anchor by its owner, J.W. Guy, and remained the east end of the Drag for years thereafter. (BA.)

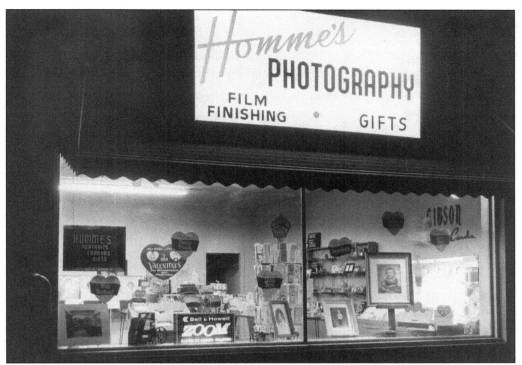

This picture of Homme Studios, across from the post office at 124 West Williams Street, captures a familiar view of "home" that one got when making a night stop to check the mail. This was later Haskell Key's barbershop. Frank Homme photographed most events of note in Breckenridge from 1954 until his untimely death in 1972. (Frank Homme photograph, Frank Homme family.)

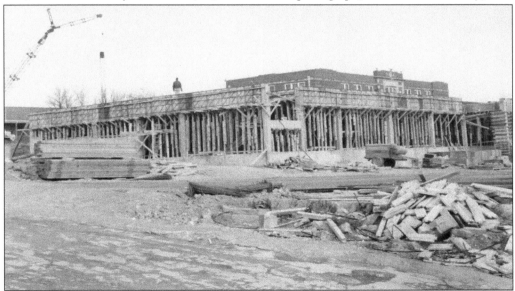

The steel-reinforced construction of the new high school is proceeding around 1966–1967. The top of the old high school can be seen in the background. The first air-conditioned school facility for the school district, it was a brightly lit modern wonder. (BA.)

Ray Berry and an unidentified postman are shown here in order to give a view of the beloved George's Café, on the southeast corner of Court and Williams Streets, which is behind them. The sign for Ann's Fashions can be seen north of George's. (BA.)

Ted Brown stands in front of his farm store in the 300 block of North Breckenridge Avenue, across from Safeway. This store sold International farm tractors and implements and also fencing and appliances. It was razed to make room for the copper-trimmed Clark Building, constructed in 1967, which remains at that site. (BA.)

Trammell Furniture was on the southwest corner of Baylor Avenue and Walker Street. It had previously been across the street in the middle of the 100 block of East Walker Street and then downsized back into that space for a short time after leaving the building pictured here. ABC Printing is now in this location. (BA.)

Lady Bird Point overlooks the mile-long bridge over Hubbard Creek Lake. This is a favorite spot for people to contemplate the majestic view and gather their thoughts in solitude above the highway. It has seldom-used picnic tables available as well. (BA.)

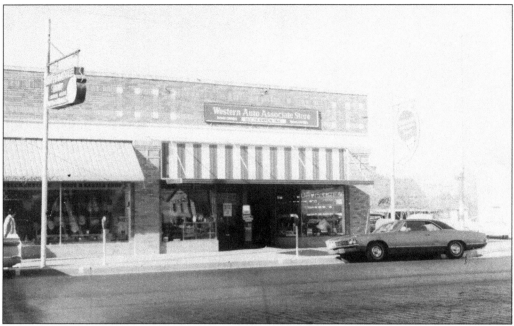

The Western Auto store on the northwest corner of Baylor Avenue and Walker Street was operated by O.C. Heairren Inc. beginning in 1965. The Boot & Saddle Shop is next door. (BA.)

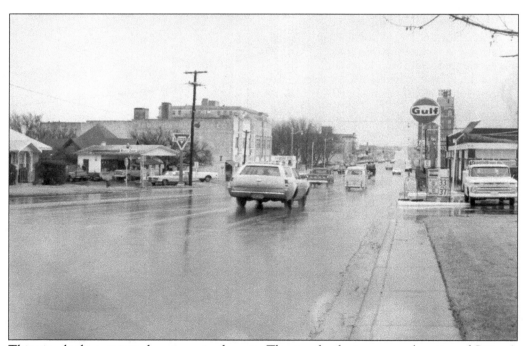

This view looks east into downtown in the rain. The sign for the temporary location of Citizen's National Bank in the old Safeway Building can be seen on the right past the Gulf station and dates this picture to 1963–1965. Across the street is Magness's Conoco and Nail's Café. (BA.)

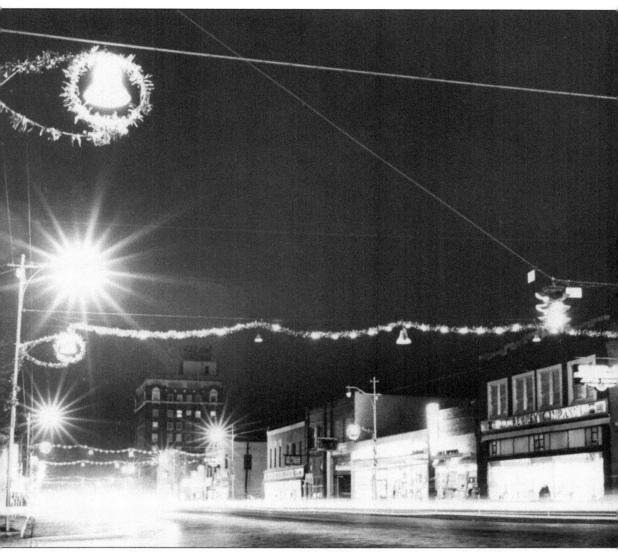

This early- to mid-1960s view shows downtown Breckenridge lit by its Christmas lights. Visible are J.C. Penney's, Peeler's, the new Ben Franklin, and Woolworth's on the corner of Walker and Court Streets. Across the street is Sears after its relocation into the old Winn's 5&10 location. Every Christmas, the downtown shops would stay open at night for a few days for downtown shopping, and Christmas carols were played outside for shoppers' entertainment while strolling between stores. The town felt like the Big Apple during these times. At a time when outdoor Christmas decorations were cost-prohibitive for all but the well-to-do, downtown Christmas decorations were particularly exciting. No one will ever be able to manufacture or recreate Christmas lights as perfect and magnificent as those displayed in one's hometown when one was a kid. (BA.)

Martha's 7-11, on the northwest corner of Oakwood and West Walker Streets, and Paul Abramson's Red Front Grocery, by the viaduct, were the only late-night options for supplies and anytime options for questionable literature. East of Martha's is the newly built APCO filling station. (BA.)

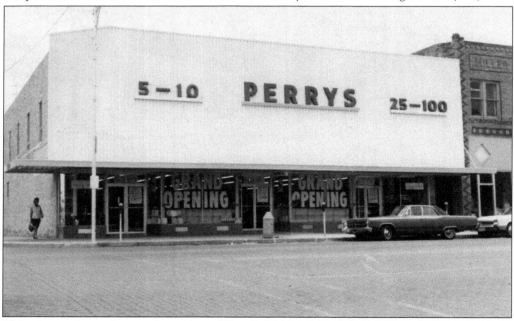

This picture shows the grand opening of Perry's 5&10 on April 3, 1967. Perry's slapped a then-modern metal facade over the old Woolworth's store on the southwest corner of Walker and Court Streets. Perry's later added a fabric department by expanding west into the former Henry Nahm's location. (BA.)

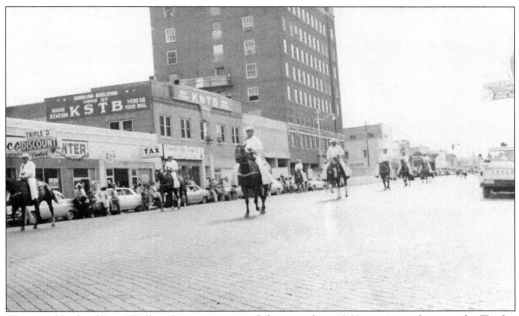

The 100 block of East Walker Street is pictured during a late 1960s junior rodeo parade. To the left is Triple D Discount Center on the southwest corner of Walker Street and Baylor Avenue, where Trammel Furniture was formerly located. Beside it is KSTB, and east of it is the beginnings of the remodel of the Burch Hotel into the First National Bank. (BA.)

This 1960s view shows Breckenridge Lumber on East Walker Street. Started by Breck Walker and Milton Daniel in 1923, it was sold to Jack Cox, who had managed it for several years, on January 1, 1956. This building can be seen in very early photographs and remained in use into the late 1960s. (BA.)

Pictured here is a Memorial Day ceremony taking place on the southwest corner of the courthouse lawn. In the background is a nice view of Perry's and Mode O Day (formerly Merrell's, White's Auto, and Ellen's dress shop). (BA.)

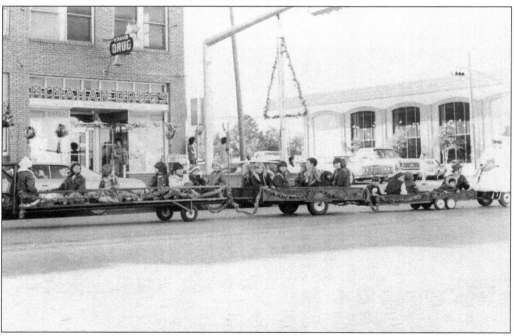

The new Citizen's National Bank opened on July 19, 1963, in a remodeled space that was formerly the Safeway Store. The new bank building, shown in the background of this Christmas parade picture from around 1976, was built in the mid-1960s. This is also a good picture of McMahan Drug, to the left, before it closed. (BA.)

The familiar interior of Nail's Café is seen in 1983 when there were none of the typical bustling crowds. Mrs. Nail baked her famous pies in her home next door and was able to maximize the use of this small space. Note the menu on the wall. (Jimmy Nail.)

Mrs. Nail served her famous extra tasty and always fairly priced burgers and other fine foods for over 50 years, up until the day she died of cancer at age 80 on June 19, 1983. The café was open the day of her death. (Jimmy Nail.)

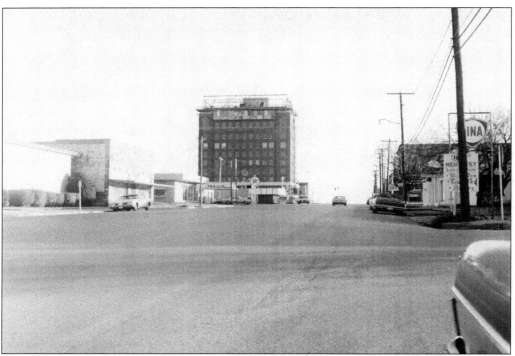

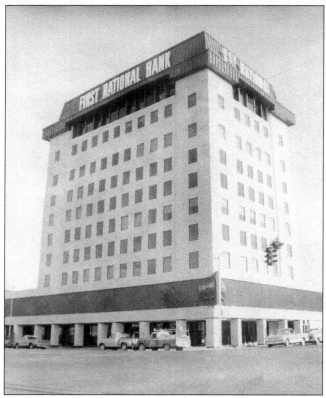

The Burch Hotel is in the process of transforming into the First National Bank in this photograph looking down Breckenridge Avenue. Mehaffey Hardware can be seen to the right and Thorpe Furniture, Texas Electric Service Co., and Duvall's Texaco are to the left. The bank moved to this new location in March 1972. (BA.)

The stately brick Burch Hotel has had its decorative stone removed, new windows installed, and its brick painted over, forever changing the look of downtown Breckenridge. While residents might long for the way it once looked, they are grateful for the renovations that have made it possible for this "skyscraper" to remain occupied, unlike the boarded up messes of many sister cities. (BA.)

A snowy, silent night in downtown Breckenridge was captured in 1975 under Christmas lights and decorations, when downtown was still vibrant and Christmas was magical. The Swenson Memorial Museum, which is preserving Breckenridge's history, is prominent in this picture in its new home in the former First National Bank building, and there is peace on earth and good will to all men. (BA.)

Visit us at
arcadiapublishing.com

CPSIA information can be obtained
at www.ICGtesting.com
Printed in the USA
LVHW111257140222
711093LV00003B/14

9 781540 200129